W9-DCF-415

19 YEARS PAINTING INTERNATIONAL CONVERSATIONS

BY THE CREATOR OF JOURNAL ART

JACQUELYN THUNFORS

Journalist Without Words

Jacquelyn Thunfors

First Edition

Riverside Publishing LTD.

© 2007 Journalist Without Words -19 Years Painting International Conversations by the creator of Journalart - author artist Jacquelyn Thunfors.

All rights reserved : text, paintings, sculptures, designs individually and in all combinations.

© 1976-1990,1991-2007 all art works in this publication. No page, partial page, partial aspect of a painting, drawing or any written material in this book may be reproduced, stored in a retrieval system or transmitted in any form or by any means -electronic, mechanical, photocopying, recording or otherwise without written permission of artist author Jacquelyn Thunfors.

ISBN
9781424329373
LCCN
2006940896

Riverside Publishing LTD.
P.O.Box 814
Southport, Connecticut, U.S.A.
06890

Printed by
Realtime Printing Co.
3266 Jin du Rd.
Shanghai, China

Dedication:

Iris Chang was a Chinese writer I never knew. She grew up in my flat cornfield state of Illinois, the daughter of two Chinese immigrant scientists.

Iris became what I thought I always wanted to be : a first class international journalist with first class educational credentials.

But her specialty, uncovering evil deeds and universal political manipulations of truth, sanitized by history, was possibly, at least partly, the cause of her early depression and eventual choice of suicide at age 36.

Her 1997 book Rape of Nanking was her masterpiece of research , unmasking the carefully hidden story of bestial atrocities against the Chinese people by Japanese soldiers for seven long weeks starting December 13,1937.

This book is an attempt to celebrate her life and work by offering ideas that could become an antidote to this ugly forgotten Chinese Holocaust she helped to peel apart from established history for all to see. Remember . And to learn from .

I hope it will become an inspiration for young people growing up like us, in the midlands of our country , to decide for themselves what endeavor is actually worth dedicating one' s life to.

Swimming upstream, against "factual" and "historical" currents, is the true midwestern way of discovery.

Jacquelyn Thurmore

Introduction

It is not my purpose to give the how, why, where, when of international exhibitions. It is my hope that, by sharing my nineteen years of experience, the reader will get a more authentic glimpse of the real life situations one encounters when one attempts to share "conversations" with people of other cultures, whose language one cannot usually speak, whose books one cannot usually read.

Forewarned: I am a "journalartist" - a trained journalist, untrained in art. Terrified before I open a paint tube, choose a brush. How to construct a conversation with colors on a flat surface? A conversation I cannot get out of my head. The stranger who will see it possibly will not "hear" it. But I must not think about this. I must not think of it as having any value beyond my own need to speak. (And I am well aware that, if you ask me to specifically paint something, I will probably not be able.)

Therefore the person that is most shocked to find themselves a survivor of eleven international shows is me. Someone must have been able to "listen" to these paintings. Many someones. One show has led to another, the "listeners" inviting me onward - Mexico City, Hawaii, England, Spain, South Africa, China.

And now, looking backward at myself, stumbling along and trying to speak without words, with strangers, about our shared lives together on this planet, I recognize some of my experiences, in assembling these exhibitions, could prove helpful to others.

Without an agent, without government or embassy help, no gallery behind me advertising my virtues, the viewers themselves have invited me onward, country to country. By now I seem to be able to see a somewhat predictable pattern emerging. Also, possibly, a new art discipline: "journalart". Perhaps the way to get others to join me, in reaching to form bonds across many cultures, is to tell here some of the madness and bliss I have endured in bringing this working concept into fruition.

Instead of giving you a linear progression, I think it would be better to randomly include you spontaneously into some of the scenes along my 19-year way. You can then experience for yourself the swimming, the sinking, the implosions and explosions of ideation that I have survived, to get these collections shipped into a far-away lap, then into the consciousness of both the well-read and the un-read, scholars and street cleaners, the donkey men, garbage collectors, surgeons, plumbers, carpenters, waiters, many of whom have never gone to an exhibition or considered purchasing a work of art.

This last lap is the most perilous for me. Will they like it? Will they understand the jokes? Will they feel connected to a stranger who has made an assumption about what to talk about? The terror of painting that conversation months ago now pales. It is now too late to change anything. Too formidable to contemplate are what the shipping fees will be, back across the ocean - framed heavy crates instead of rolled canvas and paper in light carpet tubing. I am unrealistic. I am scared. But I have been invited. I have been trusted, because of my last show, so there must be something about the way my ideas go through my hand that makes people in this next country want to hear what I have to say.

I will be bankrupt. Many currencies are much lower than mine. But I can't paint at all if I consider what will sell! Obviously I am totally at fault. My premise has no guarantee of reimbursement. I am locking myself into an international artistic cyberspace where value is only in the eyes of the unknown beholder.

So I must have arrived at a place in time where reimbursement becomes irrelevant. I keep remembering a famous minimalist telling my daughter Kristen, "Without an agent you can't get anywhere." I know full well there are over 600,000 people in NYC who call themselves artists. They must get reimbursed or expect to.

But all I know for sure, by now, is that, finally, my work is not irrelevant. Others have begun to come forward to worry about reimbursement. By now I recognize that I want to teach other journalartists to take the same risky path, reaching silently to others in countries whose language they cannot speak. In order to escape the nationalistic enculturation that often breeds mistrust and misunderstandings, leading us all once again into the violence we now define as century number twenty, it seems worthwhile.

Jacquelyn Thurmore

October 2002
Pretoria, South Africa

She sits beside me in her royal blue silk gathered skirt, large gold rayon shirt buttoned at the bosom with a flamboyant bird of paradise, its enamel worn at the edges by favoring fingers. Her turban of orange cotton is tucked tightly at the ears with a brass decoration at the side for security. Some teeth are missing.

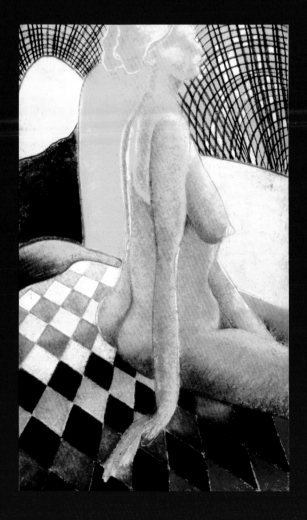

Her blue carpet slippers and swelling hips pouring over the edge of the metal chair make me feel we're both at home on her sofa instead of in the midst of 57 paintings in Pretoria Academic Hospital, Dr. Savage Rd., South Africa. Once a spotless quiet corner of antiseptic precision, the dingy waiting room across the hall of this government hospital floods with an average of 600 people a day. Tired battered furniture. Tired battered admission agents. Bleeding children. Fainting grandmothers, dozing relatives give the space a contemporary "state of the government" air. My exhibition space, the "under construction" emergency ward, will soon give a new face to the ancient hospital, belying the street scene where male patients in striped bathrobes stroll the awninged fruit stalls for grapes, oranges, apples.

When anyone asks which government hospital I have opened the show in, I always reply, "You know, the one on Dr. Savage Rd., where the guys in bathrobes buy fruit from the lady in her wrap skirt, under the orange umbrella beside the old emergency gate".

They all find me.

"Now I want that painting, miss." A large pastel yellow and brown nude sitting on a Zulu design quilt.

"Well it will be a lot of money, you know." I have put out no prices, no prints. The rand is 10 to the dollar. "I have some prints of it." I get up to find one.

"I don't want prints. How much?"

She is raising her voice now. She is my black grandmother. I am her baby. She is forcing me to name a number.

"Well, if I ever decide to sell it, I was thinking 8000 rand." The cheapest I have been advised to sell anything here. $800 for me, frame $100, net $700. For her, 10 months' wages, maybe 1/2 of a decent shack to live in. No one can afford paintings. "Well take it out of my pension."

She is one of the cleaning staff: Dressed to go home, I cannot let her succumb to a piece of paper and a sheet of glass. "You don't want to do that. It's not that good. It's really too big for most walls, don't you think? You'll get tired of it. Do you really love it that much?"

"I hear you do workshops. I have a daughter who thinks she wants to be a painter. If I send her, how much?"

"I don't charge. That's a wonderful idea... if you could help her find a group of five friends..."

"How can you be any good if you don't charge?"

1997
Hydra, Greece

Axel Ball, my Mallorcan son-in-law, stranded by weather, refused to fly Olympic Airways from Barcelona to Athens with his two children and their Swiss friend "because they will fumigate us". A later Iberia flight lands him in Athens too late at night to catch the Flying Dolphin to the island of Hydra, so he takes them to the only hotel he's heard of, the Grand Bretagne.

$1000 poorer after breakfast, he swears it was worth it, even if one of the children's new pair of running shoes is stolen from the baggage enroute. He saved them from the smoke.

When I first came to Athens, the sight of hundreds of young people smoking the siesta away, in the Plaka and bars of Kolonaki, convinced me I had to say something about it. But how? I considered this problem every single day from 1997 until three weeks before I opened the Greek show, September 3, 1999.

Accepting this municipal invitation was terrifying in itself.

Self-taught, I was completely intimidated by the history of Western civilization, the mythology, the Turkish enslavement, the German atrocities, mass starvation in WW2, the Balkan mindset, the religious entrenchment. For a year before I agreed to "speak" at the Melina Mercouri exhibition hall September '99, I spent months in my Spanish studio studying once more the entire Mediterranean basin: I put on their wars, re-read their history, slept with Pausanias, listened to Edith Hamilton, considered the nine owners of Crete. My left brain acquired a Greek mindset.

One can't moralize. One can't preach.

One can't demonstrate, in an exhibition, that one comes from a country where 20-plus years ago the scientific evidence was in: the only way agreed upon to achieve a non-smoking society was to make it so socially unacceptable that one would be considered uneducated and lower-class to be a smoker.

But my subconscious smoked! How to confront this?

Over 25 years ago busses and restaurants in Berkeley, CA, refused to admit smokers. My own cigar-crazed father even dared to ask me if I was going to throw out the ashtrays in my home, like everyone else, and deny him his greatest pleasure.

Now I had agreed to exhibit in one of the most glorious centers of civilization with a DNA inheritance most of us are jealous of. Yet young and old, all around me, are addicted.

Three days before I returned to Athens with the last of two years of paintings, a month before the opening, I was filled with depression. None were about smoking. What was the point, I asked myself, of doing all this work and not facing up to the opportunity, as a stranger, to get across to Greeks the scientific evidence that they were killing themselves, and their babies as well, with second-hand smoke.

As many museum and guide books as I always buy, I keep them around me in the studio mainly for the comfort factor. I.e., if so many ancient people, without art schools, did so many beautiful things, their descendants would probably forgive me for trying to "talk" with them, even if I stumbled in the terrifying process.

So I flipped through Greek museum photos in last-minute desperation. Quite strangely I felt myself back in Hania standing in the midst of dozens of sarcophagi - the ancient clay boxes made for holding one's bones after the birds and worms have helped your flesh into the universe.

I had always felt these "boxes", beautifully decorated, trying to talk with me. (Sort of like the way sets of teeth my dentist always had on his counters, entertained me with their imaginary conversations.) And they were in every single museum, a common denominator.

Within minutes, I knew what I had to do. As a first step I had to draw one that looked feminine and another that looked masculine. They could talk to each other about the lost DNA and my point of view would disappear!

Now I was terribly excited. But also depressed. I would have to copy two things, which I had never done, in order to accomplish the end result. Much happier painting from my imagination, there was now the first feeling of guilt I have ever had. I would have to use the designs of two other artists-thousands of years dead with no copyright attribution-in order to achieve my goal.

Miraculously, while I assembled a flat dry surface to copy their concept (filled both with guilt and boredom at having to resort to what I consider this low creative level of work) I saw in my mind the last English words I had read in the Plaka.

Early on the morning of our departure, the nearby Folklore Museum was just opening. I ducked inside past a yawning sweeper to quickly have a look. Upstairs was a wedding tableau, and beside it on the wall, translated: "I am your fate. You are my destiny. I shall have you and you shall have me, my darling..."I wrote it in my notebook.

While I copied the box designs and surrounded them with a smoking gray color with pastel, I knew I would have this Greek wedding ceremony written in Greek across the top of the painting with, below it, "Then why did we both smoke?"

Comforted that the ancient Greek grandparents in my stolen boxes were the best moralistic vehicle I could come up with, I packed my clothes and carried the drawing under my arm onto the plane two days later.

At the time, I did not recognize that this is a pattern of behavior I always exhibit when I accept the responsibility of an exhibition. I had done it before and I would do it again before the South African show. Only recently did I realize that I refract the lives of others entrenched in their culture-their habits, fairytales, politics, religion, history, etc.-but there is always a statement I want to make, from my own point of view, that I never seem able to resolve until the very last minute.

It is always very important to me. It is a challenge of sorts to the viewer. It makes all the other works worthwhile to me, for some hidden reason. Of course, no one has ever bought one of these "statements". But everyone mentions being affected. People bring mothers, friends, grandparents, husbands, lovers to the shows, just to show them what I have "said."

"So. What is this supposed to mean?" A beautiful 18-year-old Athenian girl in leather, gold shoes, chunky gold jewelry, confronts me accompanied by her boyfriend.

"You can have my Swedish DNA and I will take yours." She stares at me. Silent. Imperious.

"You are very beautiful. I am sure you have beautiful friends. Your boyfriend must be very proud of you. (He looks the other way. Impatient with disdain.) You have a great deal of power and you can influence people. If you're in the mood. "

I always try to be semi-detached like this. I'm old. They're young. What have I got to lose by being invasive? She smiles. " And I smoke?..."

" Well, the problem is just statistics, you know. We know you will probably die younger than normal depending on your grandparents and all the genetic thing. But that's just science. The thing is, with this drawing I just wanted to tell you that if you came to New York or San Francisco and were having an elegant dinner in an elegant restaurant with your beautiful dress, your beautiful hairdo and lighted a cigarette people would secretly decide that you were uneducated and didn't care about your body. They would probably feel sorry for you and not want to know you.

But of course, if you just plan on staying here, you don't have that problem. It's not fair I know. But I'd feel guilty somehow, not telling you in advance, just in case you do decide to come. And just in case you want someone to look up, like me for instance..."

More silence. Potential limitations of beauty are never good subjects. She stares at me. I don't know if it is "how dare you?" or "really."

"You know, if you considered not smoking, many of your friends would probably follow. Beauty can have real power. You can just be arm candy for some guy or you can be a power in your own right. I have four daughters so I'm probably biased and they would probably be shaking their heads at me here for invading your privacy... but you asked... and here we are..."

I trail off here miserably. I know I have given her every reason to despise me. How else can I repay myself for doing all this work? Some things matter more than others, I console myself. I am trying to save lives. It's my idea of earning "money."

Same girl-evening-one week later-walks past me as I am talking with others. Glances back, as I spot her in the crowd, and mouths, "I quit."

Reimbursement. No cash.

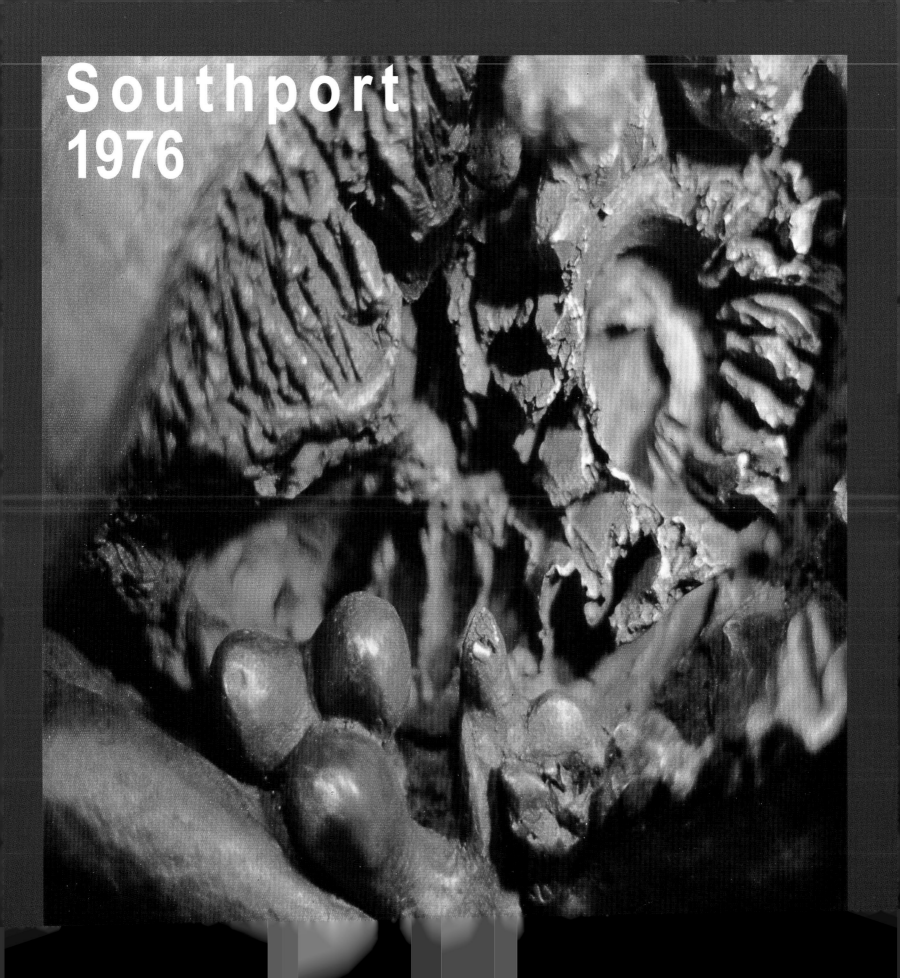

Southport
1976

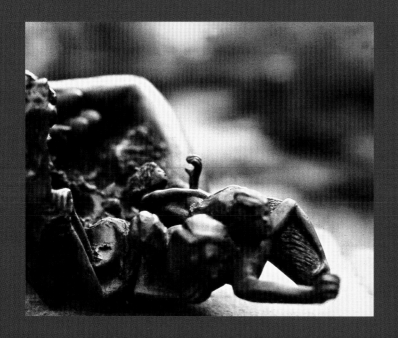

Opening a half full can of clay to add to a sculpture I am working on, my eyes see children, the inside of a hand, the inside of my upside-down womb.

Terrified, fascinated, puzzled that I had never considered an idea like the one I am visioning in the crude clay, halfway down the 25-pound can, I go to the garage. Find a rusted metal cutter. Carefully I cut the can from the clay. I peel it away in a spiral. Before me, for the first time, was a "work", in crude form, that I recognized as my own subconscious.

It was only a matter of hours before I perfected this instant sculpture: five children coming from my womb as I envision it, while on the underside we are held firmly by a large hand of fate.

"My Unborn Children" was an instantly satisfying look into my own psyche. For me, a lifeline marker. It was an instant scolding reminder that I had not recognized the moment when I could no longer have children.

I always visioned myself leading my life, controlling. When I looked into that can I saw, literally, the children I would never choose. And I stared at them, grieving. I had not willfully given them recognition, consideration. Or mourned them properly. The clock had aced me. My ability to make brains had vanished.

Three days later a portrait-painting friend, older, came to see my studio the first time. She touched this clay piece and pounced: "You are not a very good friend. You did not ever ask me the reason why I do not have any children."

"But Evelyn, that is a personal thing."

"No. It's not. Not if you are really a friend. And you go and make this!"

A few days later I told Stanley Bleifeld, a sculptor I worked with, this story. I asked him if I should keep sculpting. It was obvious now that my work could provoke violence.

"That's the reason to keep going."

At the first UN International Year of the Woman in Mexico City, 1976, this piece was purchased by Jan Tyler, professor of psychology, Brigham Young University. Unable to have children, she told me having this bronze on her desk would always remind her that even women with large families, like mine, share the same angst.

She sent $30 a month for the sculpture, refusing to ask the total price. "Just let me know when you have enough..." As she explained, she needed the comfort it provided to not feel presumptuous teaching about family life.

As an interesting aside, this gathering was the first time I ever exhibited my "ideas". I had a small think tank at the time, earning more money than I felt I deserved. I began sculpting in order to try wordlessness as a form of communication.

My friend Izabella McKamy convinced me there was no point of working so hard if I was not willing to share my ideas. This was a very new concept for me. Clay was fun. It was relief. It was easy. It was talking quickly. People did not eat it, as I later said on Mexican TV!

"But I would have to go to the foundry. How would I get them there?"

"I'll help you. We'll take them on our laps."

I was invited to lecture all over the world. But I had sold my brain in advance.

I was asked to get bids for huge installations by the largest hospital in Mexico City. Also the University of Chicago wanted a bid for its new law school. The latter couldn't afford it. An agent for the former wanted an $18,000 payment as a commission.

The agent who offered to represent me stole my work. I did not re-enter the art world for 9 years. As a painter. In color.

One indelible memory of that first UN gathering of women: the Guatemalan delegate who sat beside me at the opening ceremony:

"See the woman on the other side of me?"

A dark-haired woman, no make-up, in a plain black dress.

"Yes?"

"She's my chaperone."

"What?"

"My husband wouldn't let me come unless I was watched every moment."

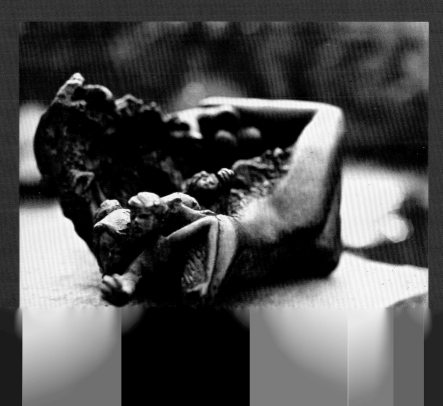

Easter 2002
Bethlehem, Free State
South Africa

In the next to last batch of paintings brought to framer Kobus Randelhoff in the small town of Bethlehem, south of Pretoria (that always reminds me of Memphis in the 40's), for the October '02 exhibition, is a piece called "In Transito". A large abstracted nude, 36" by 25" in brown, black, dark purple, I consider it unsuccessful. It is probably the only piece I have ever given up on, but which Chap, my framer in Bridgeport, CT, Kobus in South Africa, and working partner Ed Gollin all like and feel is great for an African show. Probably the reason I don't like it is that it looks like something a cubist would make for this exhibition. My instinct tells me my hand has betrayed me - it's "derivative" from somewhere.

In the Bethlehem bed and breakfast, overlooking the standard huge swath of field grass that traditionally separated black townships from white citizens in apartheid days, (with a "pass" de rigueur before blacks were allowed to cross into town) I am furious at myself.

Why did I bring this to please others? It is now glaring at me in its unfinished bombastic "in your face" tough style that for me is too obvious. It reminds me of a how-to-draw-the-masters textbook.

But I console myself that once in awhile I must listen to others, as I truly don't know what I am doing anyway. What the public prefers in painting, in my country, always astounds me. And I should be grateful so many guys like it. I should be grateful I am invited to work in this gorgeous country, where a full steak dinner for 8, with wine, dessert, salads, cost right now about $32.

Quietly the cleaning girl, this Saturday morning before Easter, begins scrubbing the bathroom floor on her knees. "You know I have to work all day tomorrow to finish this drawing. It's the first Easter I haven't been home or with my family. Tell me what you'll be doing so I can think of somebody having a proper Easter, South African style. Will you stay home?"

"Oh no. I will go to my mother's."

"In town?"

"No. Far away."

"How far?"

"Oh, by combi, maybe two hours."

"Well tell me the menu. What will you have?"

She names 6 or 7 vegetables. A chicken.

"But what about dessert? I'd love tomorrow to be thinking about your dessert."

"Oh we never have dessert. We never have that much money."

"Well, what would it cost... a nice cake or a big pie from Pic and Pay... I know you don't have time now to make something..."

"Probably at least 24 rand." She is leaning against the bathroom door frame now, in her perky turban, green and white colonial outfit provided by the owner.

I cannot believe for $2.40 I can be a little part of her Easter. She cries a bit taking the money. I cry a bit thinking how vicariously happy she will be making me all day tomorrow, as I work against my grain all day, trying to please the tastes of others.

We are twins.

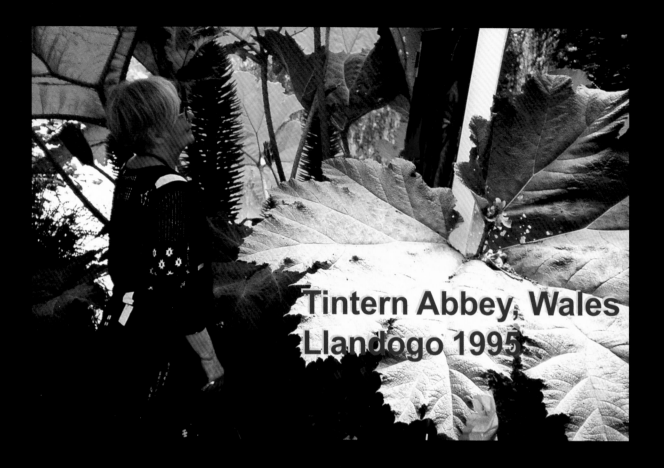

Tintern Abbey, Wales
Llandogo 1995

Conducting my first outdoor workshop after opening the Welsh exhibition in Llandogo, near Tintern Abbey, I was putting up my easel on about the third level of the uphill garden of Air Commander W.R. Brotherhood, CBE, head of the RAF in World War II, when architect participant, Peter Parker asked me, "You're not going to use your real paper are you?"

It was the first time anyone had ever expressed surprise that I always go for the real landscape - wind, bugs, dirt, toilet paper, broken pastels, stones to weight the easel - all the hazards and potential ones on the horizon.

The truth: I don't know any better. I had seen artists squinting through holes made with their hands; seen mirrors used backwards, seen people make sketches on crude paper of several possible designs.

Perhaps because of my age, perhaps because of my own idea that art is in the mind, and that it is up to me to tell you something about the wildness out there, that I never considered "designing" a landscape. Instead, with the real paper or canvas, I always grab the moment from the archaeological point of view... or the physics forces at play in the river... the color craziness of the scene or the actual history that is speaking to me in that spot.

Four or five different paintings could come out of me. If I knew what I would make of it, I probably would not leave home in the first place. It's the very excitement of grabbing, to paper or canvas, what I am thinking about at that moment, that lures me to do the work. I usually have to go to the bathroom when I get the idea I will try for.

From that moment on, in Bro's uphill garden, I recognized fully why so many paintings in museums were not meaningful to me. I could always see "he", or "she", had had a lovely morning or week. But there was no "story" in it for me, that took me beyond the painting itself.

Mostly I was seeing skill. I always wanted more.

**2002 Schaaplaat's Farm
Near Clarens,Free State,
South Africa**

Dropped off from a pick-up driven by Bruce, our Lake

Clarens bed and breakfast host, at Schaaplaat's Farm (now a horse-training

stable in the Drakensberg Mountains near the Lesotho border) I am starting

my morning near some of the earliest San rock paintings. I waste a good part

of the morning seduced by a giant tree in the pasture behind a fence that was

supposed to house a gnarled lumpy brood mare.

Escaped and finding me a new treat in the grass, she nuzzled

me again and again. Licked the pastels. Nudged my drawing arm.

By the time we got rid of her and headed for the caves,
was worn out. I shouted many warnings to Ed, trudging ahead,
bout the venomous tree viper to watch for. (Native women going
rough the forest have stones underneath their turbans, with per-
aps some mealies on top, in case the viper is hungry and will get
aylaid from going farther south.)

Very quickly we go from straggly pasture into a dense
orest of inky black tree trunks, a sullen stream leading the way
ward a very high distant rock escarpment where the caves are.

Somehow I feel overcome with emotion. This had to
ave been the pathway in , for the San, thousands of years
go. I knew from books that ahead, in a cave entrance, were draw-
gs of these prehistoric people in animal headdress, in mysterious
tual celebration. And because there are so many sites all over
frica, with little public access just like this one, on now-private
roperty, I felt suddenly alone with these tiny ancient people. Going
ere was more exciting than arriving, for me. I could feel a crowd of
em on the way to this ceremonial site. I did not want to "arrive". In
old and bronze, black and navy blue I drew that moment along that
ncient stream, feeling their voices through my feet.

Ed's photos are the real thing. My drawing is the memory.

New York and Spain
1991 and 1992

Courtesy of Ed Gollin, friend of Joe Franklin, whose WOR TV show was the longest running in New York City, I was invited to appear in the spring of 1991. Returning home to Connecticut at 2 a.m. I had little sleep. I forced myself to appear at the Silvermine School of Art where on Friday mornings a 5-hour model poses for anyone who pays $10.

Because I enjoy having something to look at once in a while, instead of trying to draw ideas from my imagination, these mornings are very pleasurable. I meet people using their spare time wisely, as I saw it, and actually see professional artists at work and many retired advertising people in action. One always arrives with a bright yellow primed canvas. I learned to mimic him and get that glow from underneath for myself, as well. The difference is, he always knew what would go on top of that glow. For me, it was reinsurance that I was at least doing something "professional!"

For me, the model is a takeoff point for telling about my life and keeping my hand happy. Trying to follow something, instead of having to invent something, is child's play. I thought I was the more normal one, because I did not pretend to know what I was doing. I definitely did not want to go home with a picture of some stranger to hide under my bed.

That morning, I was so tired I could hardly hold my arm up. I recognized I was stupid to have come. I just reverted to drawing her in triangles, made a huge vase of flowers out of triangles and was grateful for the second 15 minute break.

Betty Petschek came up to me.

"Jackie, you have never had a show have you?"

"No." I had never considered a "show".

"I'd like you to take my place. I have been offered a one-woman show at this gallery in New Canaan and I can't do it. Would you do it?"

"Why can't you?"

"I have breast cancer and I have to have an operation."

I'm sure my face betrayed me. So shocked. So upset. And me? A show? I remember thanking her. Remember saying all the positive things. Mixed in was wonderment that she considered me an artist.

Then I was home. Collapsed in bed. Just a bed, not a hospital bed. And I was doubly sure I could never have a first show, or any show, as a replacement for this brave woman.

My oldest daughter Kristen had convinced me to have a first show in Spain. In my roll of canvasses, I put the tired piece of paper with the triangles. I never saw Betty again before I left. I seldom went to the group and when I did she was not there. She was not a close personal friend. I did not have her phone number or her last name. And I did not want to think about her probable death. It would have changed my world view, her kindness meant so much to me.

By now, the paper with the triangles had assumed great meaning for me. I continually felt it talking. My instinct was impaled somewhere in those triangles.

One day in Soller, I was looking at some old postcards of the ancient village of Deya and in an instant, I knew what I had to do. Spain had joined the European Union and the prices of pizza and bread, houses and soda had risen so high that grandmothers and artists and musicians had to leave.

I would convert the triangles to a gigantic vulture with a crude beak about to eat the town - a composite of the village, designed by combining two of the postcards.

At the framer's, the owner, who spoke no English, asked Kristen if I would allow him the honor of framing this drawing in a style of his own choosing.

"But Kristen! What will be the cost?"

"Mother! This is an honor! Don't you understand?"

Typical depression-era mother, I was, from that moment, torn between the probable high cost to me and the self-assuredness of this 50ish Spanish man. He could never, ever, create a frame to give more meaning to that old piece of paper that it already had for me.

But he did.

And it sold in the first ten minutes at a price my London daughter had set: $3,000. The buyer, a banker, and collector, said the same thing as the framer: "No one has actually painted what is happening all around here."

As an aside, the collector's wife paid $7,000 for a painting, telling me she would insist on a cup of tea before paying me. Merrill, my second daughter, who had set all the prices without my knowledge, was nodding to me from a far corner.

Happy tears to this long tale of one piece of navy blue handmade Japanese cotton paper: One Friday, nearly two years later, I walked into the model group and Betty was behind an easel. I started to cry. She came over and hugged me. "I thought you were dead."

That reunion reverberates for both of us, on many levels still. She was the first one to recognize, well before me, that I was an artist. She was the first one to enable me to create a piece that preserved the emotion of the moment it was conceived.

That a third person, stranger, felt this and responded so quickly is to me what "art" is all about: A search for the other half of the conversation.

September 1999

Melina Mercouri Exhibition Hall

Hydra, Greece

Scene of an elaborate joke. Or two. One Friday before I left for the island of Hydra, Greece, to hang the Hydra collection: "Staircases, Statements and Sustenance", Betty Pia, the model, was posing sitting on a Grecian style chair. I had brought in a prepared black cotton paper spray-painted in gold. I drew her in a few moments, from behind.

The Mycaenae story about archaeologist Heinrich Schleimann, told in every Greek schoolroom and museum, is that he was so sure he had discovered the gold mask of Agamemnon that he rushed telegrams to all his colleagues and friends prematurely. It turned out to be the mask of a lesser-known king.

For fun, I titled this fast no-brainer work "Waiting for Agamemnon" because we are all still waiting, in the 21st century, to see the face of this very famous king.

Unfortunately for me, a renowned Greek jewelry designer and his local store manager fell madly in love with this drawing and did not get the joke. I lived in fear they would buy it for its beauty and discover, later, that it was mere madness on my part. Having to tell them the real meaning would surely embarrass them. I was ecstatic when I saw them leave the island on the flying Dolphin a day or two later.

The following Tuesday I heard a roar of laughter from the smaller annex where it hung, as a 6th grade teacher told the real story to his class. Praise the Lord for teachers and artistic jokes that hopefully make it easier to animate our often too-illustrious ancestors.

No one has bought this work but I now value it more. It's a workhorse for the middle school educational crowd, and it fools connoisseurs. It has earned its keep, exhibition wise.

Call from Honolulu
Two weeks before Lent

1990 in my Connecticut studio

"Jackie I'm calling to see what your plans are for arriving."

"But Father, you didn't send me the letter from the board. You were going to send me a letter...remember...last year confirming that your Newman center board requests me to do an Easter show? Remember?"

Silence.

"Does that mean you're not coming?"

"Father I can come. But it won't be as large as show as I had planned on doing for you."

"That's alright. We are all looking forward to it so much."

I put the phone down. Shock. Depression. Debate. Julie Parker, my Honolulu painting friend, had arranged for them to invite me. "They love Roe vs. Wade!" And because this sculpture has become notorious, beloved, symbolic of the abortion debate in America, (known as Pendulum of Life in Asia and Europe) I could not believe the intellectual priests of the University of Hawaii Catholic Newman Center actually knew whom they were inviting! So I requested confirmation. Eight months passed. None came.

I searched the house and studio. I had a painting of the first Catholic church in America in St. Augustine. Done for the Spanish show. I had navy and black wild Hawaiian nature drawings. A mad pointillism experiment of a seated girl I had never planned to sell. It could be sacrificed to a Catholic cause.

Maybe they'd like the huge painting of Merrill's London kitchen table with the cereals, toast, fruit, imaginary bouquet I made, for you to explore if you don't like the breakfast. A potpourri was all I could offer now. A few drawings plus Roe vs. Wade.

But maybe I could paint something more appropriate, if I went to the Friday model session and turned on a Catholic "headbeam."

I came home with one long-necked pink cheek nun, including halo, and a too-furious line drawing of an imaginary Jesus with an abstract instrument in his lap. Neither did I take too seriously, Time was of the essence. I felt I had enough work to ship a small collection to fill a chapel I had never seen. And I would save face for the Father.

Julie met me at the Honolulu hotel with a 23 year old Hawaiian boy who "frames from his house very reasonably." He announced to me curly koa was the premier framing material in Hawaii, nearly extinct, but he had a supply, and no one would buy a good painting without it.

I succumbed. Called an insurance agent in downtown Honolulu to make sure my motley assortment would be safe in this very open public space at the University of Hawaii. "Haven't you heard about Ineki? All the agents skipped town in the middle of the night. You can't even get a homeowner's policy. The state has had to open an insurance agency and there are long lines... paintings???? Forget it."

Uninsured, exhausted I arrived at Father's office to help with the hanging. Already he had the nun over his private desk in his private office. "I'm going to show her I mean business!"

He gave me an extension of the house policy. "Jesus" was grabbed by the retired chemist jazz pianist, who conducted the Newman Center music group. He hung it over his keyboard.

Roe vs. Wade? On the altar directly behind the priest conducting the Easter service. The music, the ambience? Divine.

At 6 a.m. Monday morning after Easter my hotel phone rang. It was the chemist-musician. "Jackie I know I'm waking you. I can't wait to come down and show you...I've been up all night composing music to your Jesus." A conversation that almost didn't happen. Twice.

Spain 1992

She wanted to buy something of mine but she couldn't choose. The hotel walkway exhibition space was filled with 55 of my first "conversations" with the Spanish people.

Kristen had convinced me to try to share these ideas in paint, pastel, on paper and canvas and I did not know what to expect. Deya was filled with artists then. Robert Graves lived next door. I did not think of myself as an artist in 1992. I was experimenting... surviving a crooked sculpture agent...surviving failure of large institutions unwilling to finance architectural sculpture to animate the simplistic building design cubes then so fashionable.

Actually, I sympathized with this new German friend. I would not have been able to pick one myself! I have the same feeling now as I had then. There is no "style" to help the viewer or collector. I have no style because I am trying to converse with another person about a very specific subject, who probably comes from a very different culture than mine.a different language...a different world view.

I cannot set out in the first place to sculpt or paint something attractive in itself. If that happens, it's always an accident. I actually usually try within each of my works to give the viewer a "path" to escape me. Sometimes several paths, I am so fearful of boring others.

"I know how you feel. If you choose anything it has to talk to you. If it doesn't, you shouldn't buy it. Suppose I go and leave you alone? Take your time and don't feel you need to buy anything."

I went out to the walkway to work on my newest seagrape design.

To keep myself calm and entertain myself between ideational projects, I had decided I must adopt a single plant. Flowers in general are an addiction and I knew I could easily become, in some other world, a narcissistic intoxicated flower painter. The beauty disease. Instead I knew I had to commit only to a sculptural one...one I could become expert at and that would keep me tuned to three dimensional space, along with the possibilities in color that it represents. Seagrape was the answer. I think I made three large seagrape designs just from sitting this Spanish show. (As one computer programmer told me, "No offense. But if I could paint, that would be the ultimate for me." Exactly.)

Twenty five minutes went by. This is a woman who regularly in 1992 spends $3000 a week at a well-known German spa. I was sure there was nothing in there for her. She was probably terrified to come out and "fail" me.

The door opened

"Now Jackie I've found something."

"Really? Are you sure?" "Yes. And I am sort of in shock."

"What?"

"Well you know in that far corner is a mysterious drawing that has like parts of musical instruments, notes sort of becoming flowers, kind of a wild big thing..."

"Yes. My daughter Merrill in London did not want me to exhibit that because she loves it. And my daughter in America didn't think I should bring it because she felt it wasn't good enough! So say what you think. Nothing bothers me. I have no idea what I do, really. It's all like impulse... more like things pass through me and I grab them."

"Well Jackie did you know my mother? She was a well-known German Leider singer. She used to stay with me and sing in the shower and I could have killed her, it was so maddening. Then two years ago she died. Suddenly, I would give anything to have her back. And Jackie I did what you said, piece by piece, and this one sang to me! I can't believe it. It's like I found her."

I still get goose bumps when I tell this story. If you can't find your "conversation", I won't let you buy it.

Several times, by now, people have called to say "I'm sure you don't still have that painting. I just can't get it out of my mind. Is there any chance you still have it?"

One European owner of a large painting from the same show came to America for a two year stint and gave the work to her mother for safekeeping. When she returned her mother had become so used to "feeding" from the concept they had a huge argument before she could get it back.

It's not that my work is "good", whatever that means. It's that it is one-half of a conversation looking for half number two. I've discovered that if one member of a family discovers the "right" painting, the others usually concur.

South Africa 2001

In Clarens, Free State, South Africa is a very special flea market where one can buy original art, handmade sweaters, Xhosa crafts. a rural Drakensburg Mts. arts community, on a plateau overlooking the local black township, Clarens has become a focal point for weekend tourists visiting the famous Golden Gate Valley on the Lesotho border.

Here one can meet Al Tiley, retired submarine commander; the waitress widow of a Zulu forestry manager, who was murdered carrying the payroll to his crew; bookstore owners Debra and Ken Stewart who have a little printing press in the back room; chefs at several tiny unique restaurants who focus on regional specialties etc.

On the morning I was there Lisa Van Wyk was behind a small card table displaying hammered 8" square pewter designs of little girls with pigtails flying in flower and weed patterns.

Three days before I had chosen the first of the frames for the South African show with framer Kobus Randelhoff in Bethlehem, who was introduced to me by Johan Smith, owner of a local Clarens art gallery. To my shock, most were imported and extremely expensive. I realized this exhibition would cost more than the Greek show, even if the rand was running very low. Lisa's plaques were backed by beaverboard (masonite) and very inexpensive.

"Tell me, have you ever thought of doing frames?"

"Not really. Why?"

"Well, I am framing a large show for a government hospital in Pretoria and I find all the frames are imported. You could probably do the most wonderful things in copper. If the price was right, I could order quite a bit."

"It shouldn't be that hard. But when would you need them?"

"By next year. What is your life like?" "I have an 18 month old baby."

"Perfect! Your every day is filled with 20 minute periods when you don't know what to do. That's great for repeat design!" We both laugh in instant universal recognition of the realities of motherhood.

"Exactly."

Lisa shipped to Connecticut at least 10 design samples in different widths - Zulu triangulations, hunting San action stick figures, etc. Some in copper, some pewter, some with four color Ndebele patterns on each side. The latter I recommended she turn into mirrors, as the colors were too attractive to house images.

Eight of her designs I used for the show, at a price much less than the available imports. She shipped them direct to Kobus. And to my great pleasure, Monica du Plessis, editor of the Sunday Independent magazine section in Johannesburg, mentioned Lisa's work in her full page review.

A minor glitch, which could have been major with two lesser individuals, Lisa failed to convert inches to meters correctly. Kobus reassured her he could solve it. He made huge handmade copper corners to make her work fit.

She was so very indebted to him, and grateful, and he so admired her work, they have become very good friends. Before I left the U.S. to come to South Africa to open the show, she called me ."You know how you said your real purpose was to help people start their own businesses? Well I hired an assistant today. You can just stay home if you want!"

[Editor's note: By 2005, Lisa had 8 employees in her decorations and frame business]

1991, 1999, 2001
Spain, Greece and China

Only in 2003 did I discover a pattern in myself. When I have an idea I cannot get rid of, I work quickly because I am sure it will go away.

When I got off the plane from Madrid in 1991, I had conceived 7 ideas for paintings on 7 cocktail napkins enroute home. Leaving my suitcase in the living room when I arrived, I went directly to my basement studio and threw the rough concepts on before they vanished. Four later sold immediately. I had "felt" them in the air. One was about the Maastricht Treaty... the nightmare of having to get everyone to agree. Another was about the Mallorcan land...how everyone derived their pocket money from the red, red soil. Another was about Anna the cook, who would not care about olive trees except for the oil they produced, that made her reputation at the stove secure.

Thus, I have no actual memory of "making" a painting...it's more like quickly capturing the feelings and secret motivations of the people who will be looking at it.

When I enter, for the first time, the opening of one of my shows, my first true instinct is to buy something! My second thought is "You're an idiot. Look deeper...you made all this."

How does it happen? I only understood myself a bit clearly when I was in China the spring before last, at the invitation of my friend Chung Yeh, who made plans for the Shenzhen government officials to meet me. They provided me with a government apartment at low cost and introduced me to their finest local artist, Guan Yuliang,

Touring his work storage areas, he pointed to a pile of precise
stretched canvasses nearly as high as my head, identical in size, about four
foot square.

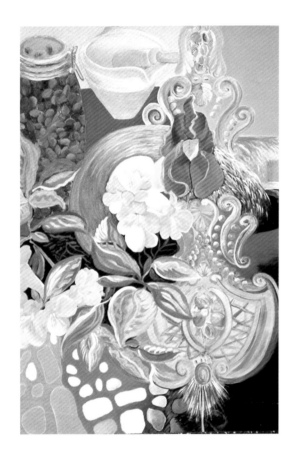

No. I never know what I will do. I never know what
size it will be or should be. So I make a kind of Montessori kinder-
garten situation for myself, both when I am having an exhibition and
in between. I purchase a big batch of stretchers, mixed sizes. I like
big. I like odd shapes. I hate pairs of anything.

I sort of feel the possibilities of space, the way Charles
Eames did with his first house, i.e., if it is big, will I get scared? If I don't get
that big an idea, am I wasting this stuff by stretching it? (Matisse, with no
"ideas", and a vast expanse of tablecloth poorly rendered, is my idea of
misplaced ego.)

Note the word "get" here. I always plan to get ideas, not
scheme. They will arrive. I will hopefully have a proper "nest" to house
them. It's almost embarrassing for me to type this. It makes me look like a
sangoma or a shaman. Maybe I am, but don't dare look in the mirror!

So I continually have primed mixed sizes of canvas hang-
ing about. Sometimes for years. The danger is, I am so irresponsibly spon-
taneous that in one instant I can inflict something on one of them, with no
further concept ready for the entire piece!

It was only in assigning myself this writing project that I became
aware that on three different March 25's, in the past 15 years, without
a second thought, I have gone straight to the studio and roared around with a
brush, the most perfect iris in pure delight.

On huge primed canvas. Kristen and Axel, her husband, always send this celebratory bouquet for my birthday. Because the paintings were done in such disparate years, I did not see the pattern. In 1991, I put a huge vase of them in the exact center of a 5 foot green canvas, painted the iris in all their variations, and went to bed terribly content with myself.

The next day my youngest daughter, Lowell, seeing what I had done, said "Mom! I don't believe you. You plunked that big bunch of iris exactly in the middle of that huge canvas. What were you thinking? You never do something like that. Now what?"

Two years later I was still asking myself, "Now what?"

That was the first time. Then in 1996, I put another huge bunch in purple and black on a stained red 5 x 3 ft. empty canvas and in 1998 I did individual portraits of 10 iris across the top of a 6 ft. yellow canvas, the stems hanging down in the middle!

Proof , from my point of view, that I have no artistic memory. I cherish the gift of love all the way from Spain and I ACT on it.

Eventually, I "rescued" these three. They caused me agonies I will not relay here. Exuberance over-whelms me when the florist arrives. I seem to give immediate birth to a baby that needs raising. And I give birth to her in huge panoramic spatial terms, as I always have a canvas ready to "catch" my most important emotions.

Obviously, I see now, they actually catch me.

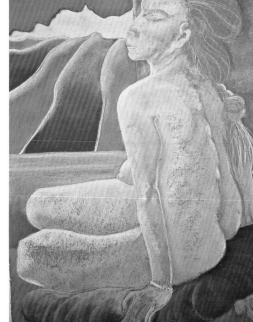

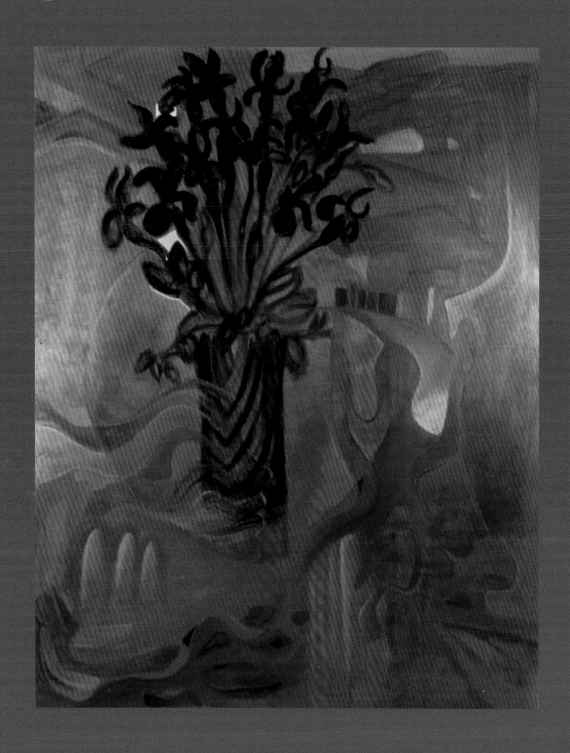

Hydra, Greece
September 12, 1999
Anna

During all my exhibitions there are people who return several days. There are those who come every day sometimes. They sit there and stare at my work. They stare at me. Some tell me I don't look like an artist. Most tell me I don't dress like an artist. (My daughters always ask "But what will you wear?" because they know I never give too much thought to it, knowing, if I focused on my clothes, I would never paint at all. It is such more serious stuff, what one wears.)

One never really knows what to expect. An elegant Parisian woman, for instance, came early one morning to the Melina Mercouri show and stayed all morning. When she had been sitting for another 45 minutes, I asked if she had enjoyed the show. "Yes. But I thought you would not be so modern."

Another woman, about 45, in a sleek pantsuit, modern silver jewelry came several days and spent time drawing at the children's art table I had set up in one corner. A consultant in Brussells for the Economic Union, she relished the idea of digging into crayons, pens and paper all by herself, in that corner.

However, the person most memorable to me at the Hydra show was Anna. I do not know her last name. I will probably go to my grave trying to find her.

Tall, dark hair, oriental in an exotic offhand way, I could not help but notice her as she sat quietly to one side in contemplation. There was a large crowd that afternoon. Tourists, bathers, shopkeepers, other artists I knew.

In a pause, she went to the piano and took the guest book back to her chair, looking at each page carefully. I sat down beside her, wondering what the Greek guests had written. She told me, if I could read it myself I would recognize that a large number were poorly educated, barely able to write at all and that they wanted me to know how close they felt to me, by my work.

"The wealthy people here write beautiful things to you but the vast majority are struggling, in Greek, to talk with you. You should be very honored".

"Thank you. What's your name?"

"Anna."

"Do you live here?"

"No. I am a student."

"Shouldn't you be in school"

"Yes, but I am taking a rest. I live in Athens. My father is Japanese, my mother is Greek and there are many problems. I am feeling unsettled...the earthquake and everything."(A week earlier Athens had suffered a massive earthquake, which also touched Piraeus, weeks after the giant Turkish quake that took thousands of lives.)

"But where is your school?"

"In Kiev. I study international law...my last year."

"Really? How did you chose Kiev?

"It's a crazy story...I fell in love with the architecture... it's so beautiful!"

Japanese, Russian, Greek, English...I was stunned by the brilliance that shone from this girl.

Someone interrupted us. When I turned around she was gone. She had not signed the book. Troubled and obviously persevering against great obstacles, she was one of the most memorable women I have ever met.

The following night returned a group of rowdy London filmmakers, who were, in reality, trying to seduce me to loan them my new digital video camera. On the pretense of needing to sweep the upper entrance after a rain, I opened the huge doors on the upper sea side. My broom hit what looked like a wallet.

In the light of the exhibition hall, it was a tiny leather book written to me by Anna. She mentioned the inspiration she found in my work, especially my tribute to Chadwick, who co-discovered Linear B with Ventris, establishing it as a true Greek early language. In the Encyclopedia Britannica there is no reference to him. The reason: he wrote the listing and gave Ventris the entire credit.

Somehow, after seeing the collection, she said she found the energy and courage to return to finish her degree. Her handwritten tiny leather book was just signed Anna. Her e-mail returns "unknown".

It is this kind of experience that keeps me on the road and keeps me painting. It is this kind of person that my work discovers. Not knowing where she is, who she is, how she is, is an everyday sadness.

Both giant, fat, 4 ft. square boxes of drawings come from the fragile section without a hitch. The tall carpet tube with the paintings follows, intact. Two carriages hold the entire load of luggage and paintings and we head for Nothing to Declare.

Just beyond the last section, I could see Bokatsas, sent from Vassilikas, the framer in Peristeri, and I knew he had a truck ready to load all my work. He waved. I felt so organized. Relieved to have found such wonderful people to help mount this huge exhibition on Hydra, two hours away by boat.

Two tan uniforms come from an unmarked side door.

"What have you there?"

"Paintings for a municipal exhibition on Hydra."

"We think you will have to undo them and go through customs tomorrow. They're closed now."

"Are you sure?"

"I'm sure" the partner chimed.

"But they're for a municipal show. I'm your guest. They're not for a gallery."

"Sorry."

Bokatsas has come forward into the exit arena. He speaks positively and in a very friendly manner to them both. They listen. They shake their heads. He talks some more. They listen, shake their heads, and take the three units.

"We open at 8 in the morning. Come to that long shed over there."

At the Nefeli, in the Plaka, we try not to be depressed. Nefeli represents the Lonely Planet's paradise: clean sheets, canned orange juice, no TV, no sink plug, no money. Perfect for us.

If we can get through customs in the morning, will Bokatsas come back? How much money can they demand, now that they have all the paintings? Why do I have this new life, where nothing is prepared for me in advance? No itinerary on a typed slick sheet? No friendly ambassador from an embassy, waiving me through with official papers? How much sleep can we possibly get if we have to return to the airport by taxi, getting there at least by 7:30 to be near the front of what I envision will be a long line of people like us? The innocents. The stupid. The optimists going against all the rules backwards to boot. Seven hour jet lag, plus 6 hours Nefeli anguish, equals worse jet lag.

stoms
99

Nights like these underline the rawness of life without an agent or backer. This is the ragged edge of what I continue to do. New country where I do not speak the language. Greek payola heaven, gigantic no-place-to-hide boxes of work. Truckers eyeing an easy sucker. Customs agents trained to circle American dollars. Taxi drivers tripling the non-existent meter for exotic bulky luggage.

In-transito is as bad as it sounds. Leaving and arriving are paradise by comparison. At 8:05 we are in line at the customs house. Smiling, relaxed, ready to tell our story.

Mr. Litsacos is dapper. Tan slacks, white shirt, sports jacket and cigarette, he looks me over. Gestures toward the carpet tube and boxes.

"What have we here?"

"The last of 65 paintings for an exhibition on Hydra. A municipal show."

"What's the value?"

"I have no idea. Maybe nobody will like them."

"What is the value?"

He is trying to be kind. And patient.

"I don't know. They're not framed. It could be anything or nothing. Really."

"Ok. Ok. Open them up." He gestures to a worker to get a knife.

"The repacking will be a nightmare. I paid $100 to have these professionally packed for shipping. And they have to go on a truck to a framer in Peristeri. I purposely am doing all the framing in your country."

"Then call Athens and get someone out here to tell me the value. That's the only way."

He points to the phone. "But I don't know anyone to call."

"Find someone."

"This is a government show. I am an invited guest of your country. There is no gallery behind me. I have no agent..."

"Then call someone!"

He glares at me. My partner glares at me, the whites of his eyes saying "Let the next person in line come forward... just leave them!...find an answer some other way...You're making a fool of yourself. You're embarrassing me."

I cannot believe, after two years of work, it has come to this. One man. One little defiant man. I look at the three units leaning against the wall. Try to consider his point of view and not that of the next in line, glaring as well.

When in trouble I always told my children, train yourself to step back and think. There is at least 30 seconds before someone feels you doing it. Even if you're in the middle of a piano recital.

In that instant, I realized I might have a trump card right under my arm. From the big black linen carryall under my arm, I took a carefully wrapped packet. Borrowed his assistant's knife and handed him a handsomely matted silhouette photo of Kapodistrias, the first Greek president, who was named after the battle for freedom from the Turks after 400 years of slavery. Without a word.

He took off his glasses. Turned to the helper: "Kapodistrias!"

"Yes, Kapodistrias. Your first president. I knelt beneath the statute of him in Naupflion for half an hour, waiting for the sun to light him perfectly".

He looked at his papers, put his glasses on again.

"Pay $14."

"But why should I pay anything? This is all for you."

"Just please pay the $14. Everyone has to pay something!"

Ed looked like he owned the place.

In the Johannesburg airport, after the 17+ hours in the air we wait patiently for the large carton containing the 7 last oversize matted drawings and the carpet tube containing "Modjadgi the Rain Queen," "Find Your History" and the mad double-faced gorilla, that is missing the apple I will have to put in his mouth later.

Having survived a near disaster in 1999, getting through Greek customs, we are on more professional alert as we load everything on the two carts. Last to be loaded are the works which have come out of the fragile section of SAA, and are hand-delivered to a special counter for pickup.

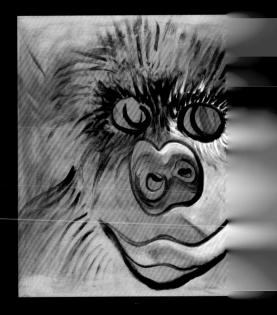

Eternal optimists (me at least) and juggling the entire load between us, we must look like pygmies pushing elephants. I am so happy to have gotten this far safely. I feel almost giddy. Despite my hard won Greek customs victory four years ago.

Ed, as usual, is much more in fear of lurking authorities and follows behind me, grateful for a large shadow. Just as we near the end of the hallowed sanctuary Nothing to Declare, a uniformed jolly man appears with epaulets bouncing and greets us with a big smile.

"Well I bet we have something special here."

I smile back. "Yes. I am so happy. I am going to exhibit these paintings in your big government hospital in Pretoria. A huge job it was. And I just hope they like it."

Ed has turned his back by now, making believe he is not involved and, I am sure, swearing at how naive I continue to insist on being.

"What is your name?"

I tell him. "And this is my 6th international show. I'm probably a little crazy to keep going. They keep

situations. I seem to lean back, in my mind, and reappear as a child strolling around our tiny square in Washington, Illinois. Way back then, when everybody knew everybody else and the assumption was, "we are all in this world together with only the best of intentions." The problem is, I really am one of those misplaced people.

By now, the agent has his hand resting on the carpet tube. He has such a pleasant face, is so crisp and spotless, his sharply creased white sleeves reminding me of my mother's ironing, that I am truly enjoying talking with him. Obviously, he is interested in what I have to say. Maybe he is just enjoying a pause in a long boring day before he pounces. We all have to animate our boredom, no?

I seem to have learned to savor these moments. My conscious mind knows I will be challenged at every entry port. New Yorker Ed lives in dread of every bureaucratic encounter so maybe I have assumed the role of his teacher? A uniformed challenge in a strange country is his idea of hell. But I look at it as a sort of opening act in a play I have devised. The "uniform" is the front row of the audience that has never met me or heard my ideas. Therefore it is my job to make the opening lines a wedge into the much bigger project. If these fail, I console myself, on that "opening night" the wrong people came. Delusional. Very delusional. But mental gymnastics is

what I do, via paint, so why can't I try to imitate my paintings?

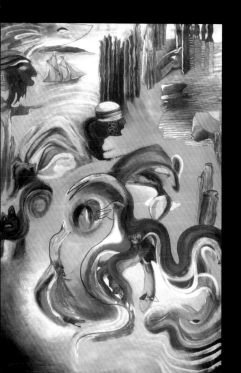

"Do you know Green Market Square?"

What? What is he saying?!

"Greenmarket Square in downtown Capetown...the art market by the Holiday Inn..."

"Of course! We spent some time there on our first trip. Amazing. So many wonderful African things..."

"Well, I can arrange for you to bring your show there. We have a non-profit organization and we donate all our profits to charity."

Ed has been visibly clinging to the edge of a hurricane. His shoulders now slump, as though an entire house has hit him from behind. He dares to look at the man.

"Really?"

"Yes, and my great aunt was Maggie Loubser, a very famous South African painter."

"Really. I don't know of her but obviously I have a lot to learn about South African artists."

I am dying to wink at Ed. Instead I slump into the conversation, floating on the custom agent's goodwill. Ed is now leaning on the boxes smiling and pale.

Here in front of me, writing his name and phone number in my notebook, is a genuine specimen of Illinois human being. He just happens to be in a South African customs uniform, verifying once again my continual belief we are all tied together. Today, my work has enabled him to be in the airport spotlight. I am re-paid already, before I reach the streets of Johannesburg.

Wilhelm Steenkamp, owner of the Pretoria bed and breakfast we stayed at during three seasons of research, as we climb out of the combi:

"How was the trip? Exhausted?"

"Perfect. And we were unbelievably lucky."

"What do you mean?"

"Going through customs..."

"Oh those people can be bastards...you were lucky?"

"Wilhelm, could you use the name of a wonderful man who helped us through, whose aunt was Maggie Loubser?" I tell him the non-drama.

"You're kidding. Maggie Loubser? My aunt knew her... never, ever, in all these years, have I had one person there I could get help from."

Like gold, the name went into his rolodex. Most of the 60 rotating new international ambassadors to South Africa stay in Wilhem's reasonable beds, before finding their own Pretoria lodging.

Wales 1994

When I can read the language of the country in which I am invited to exhibit, I flood myself with their politics, fairytales, history, poetry, mannerisms, contemporary slang, advertising campaigns in action, etc.

Poetry is particularly meaningful to me, as I can sense a compatriot...someone who has been there. Felt that. Music accompanies me, lifts me, nourishes me as I struggle to actually make my hand produce the idea.

Death is with me. Daily since I was 8. I have always been getting ready. And when I come to, after running around canvas or a sheet of paper, dancing a model, imagining a time, a place to fill the empty spaces, I often surprise myself. An image will talk back: "I've caught you."

"Remember Me" was like that. Floating above space, partially realized was me, gone. Looking down on earth. Christina Rossetti's poem, "Remember Me", said it better: When I'm gone, don't think of all the troublesome daily headaches we had to deal with, how much unhappiness, trauma I caused you or you caused me. Just please remember I was here, I loved, I learned, I was a common human struggling to become. Just remember. Let the loving aspect of me remain. We are all unimportant in the end.

Naupflion, Greece 2000

Every time I passed the entrance to the second floor municipal gallery, it was closed.

But the morning before we left, after printing the catalog, the street door was open. Maria Gomas, a local art consultant whom I had met in the nearby folk museum, had told me to try to see it. All women artists.

Rare. All women artists in two Greek rooms. I climbed the steps expecting local contemporary work in a mix that would give me fresh insight. Perhaps a new friend.

Instead, 20 or so older canvasses, with most the grayed-off color of the 20's, 30's, 40's. A guess. Trying to get a better focus on the time frame, I went from canvas to canvas to find dates. None. When I asked the man sitting the show why there were no dates, "Oh women never put dates on their work.""Why is that? I always put the date, the copyright symbol, my name. So I know where I was and when. For other people too."

"Well, I don't know really. But I suspect women were maybe not invited to exhibit much back then. Or didn't have enough spare time, raising children and all. If they put a date on it, maybe it would mean the viewer would assume, since she did it 3 or 4 or 10 years ago, that maybe, you know, she wasn't a real working artist. See what I mean?"

Ah yes.

Seldom does a painting paint itself. I always wait for that kind of moment. But it seldom comes. George Seferis' poetic concept got me going..."We are all sailors without work" set off a click. I always knew I wanted to talk about how we are all now interrelated economically. Around the entire globe. And Seferis got me instantly started. I painted two imaginary Greek conventional scenes: a sofa in the courtyard of the Orloff hotel and a swimming pool picnic scene in the shadow of an ancient Greek church in the Hydriot hills. Ho hum. Conventional four colors. Very ho hum. What next?

Southport Connecticut 1998

For nearly 6 months this weird painting stared back at me. Daring me. Seven or eight other works roared from ideation to completion around it. I forced myself, every day, to look at it. To think. To abandon? To realize how inept I was even to think I could achieve this global economic concept on two and one half square feet.

There is a glass door between a tiny apartment I made at this ground level, while working on the Worcester, Massachusetts show. It enables me to consider, at a 10 foot distance, how to solve problems I mostly give myself. Problems that are unsolvable. (And which John Dewey would advise me to accept and move on.)

As my now 17 year old granddaughter Merrill used to say, "My Nana never gives up." I get lost in a painting now and then. Once I had to ask her if she could find some more tables in a garden kaleidoscopic drawing I trapped myself in. She is a growing witness to the fact my hand has a tendency to flee my head.

But this was a big fish idea. It was not an interpretive landscape. It was a gigantic international head trip. I had it hooked. But I almost gave up trying to haul it in.

Sleeping on the foldout sofa, and looking through the glass door in the middle of the night, became increasingly important. Maybe half asleep I could stumble on the answer. Some other level of my consciousness had probably "watered" this idea. If I were to make it work, I probably had to surprise myself again. Like in the middle of the night my sleeping left brain could be crept up on. And my right could pounce: bang. Then it would be precious downhill again. Not up.

It hit at 3 a.m. on the way to the bathroom in the middle of a foggy night. In an instant, I knew I would probably have to destroy the look of the double realistic miniature paintings I had worked so hard on.

Next morning I could barely get out of bed. My only alternative: circling huge dominant white lines in and out and around the whole...the only way global exchange could be symbolized. In addition, I knew I had to construct a big symbolic seaside stanchion in the very middle, hopefully to make you realize you can't hide. You can't kid yourself. No matter how lovely your home, your things, your town, your island "escape", you are "tied up" to the forces of global economics. Forever.

I was sure no one would like it. I was sure no one would understand it. I was so troubled in finding the answer that I began to not care anymore. Why did I try this anyway? A real artist would have known how to say this. I have shown that I am truly the imposter.

I "ruined it". And they loved it. I only wish George Seferis and I could have shared a night.

Orloff Hotel
Hydra, Greece
July 1999

In the end, we shared more than a night. I actually felt he painted a larger later canvas for me. I was his happy ghost.

Several weeks before the opening of the September show, I re-read Seferis' work and tripped over "We've Returned To Autumn Again." I experienced such a simmering of retroactive memories...such a collage of green to brown,outdoors to in, vacation to work, silence to noise, donkeys to subways,brown arms to white.

The show was already painted. The invitations were in the mail. But as the Greeks say, "Why not?"

It painted itself in the walkway of the Orloff garden. And I kept secretly patting it, like fine lingerie: "You're here."

Spring 2002
South African Airlines
Anita Martin

In today's electronic world, there are people one never sees who become lifelines. In the head, as well as in action.

Anita Martin is one of these. In Ft. Lauderdale, Florida, she runs the personal services division, by phone, for SAA economy class passengers like me.

When we first met I was asking for a comfortable 17 hour seat for the J'berg flight, in that I have two replaced hips. But I do not have the business class fare to keep these hips in the style they would like to be accustomed.

"Well don't worry!" came the Jamaican song of a voice. "I will find just the thing. Like platinum I had dialed a hidden mine of pure goodness. If phoneavision had shown her on the runway, crawling on her hands and knees measuring between each seat, I would not have been surprised.

"And I have all these first drawings to take on board..." I whined, miserably unaware of how hopeless I must have sounded compared to her upbeat lilt.

"Well now don't worry. Have you got a fax machine? Good. You just send a fax to SAA, in care of me here and I will explain it all. Alright?"

I felt like fainting into the receiver. Mrs. Jesus at the other end of this wire, caring about me and my problems. Furthermore, I had consolidator tickets, non-refundable. Ever. And she already knew!

That was just chapter one: two years and three 17 hour flights, plus three 17 hour returns, and I felt, on every one, that I was almost flying in Anita's lap.

She trained me to the top deck: 18 seats, little storage space but great leg room. In transit from J'burg 6 crucial drawings were lost. The sleepy black check-in agent was intent on telling me his dream last night and the drawings never got a number. Actually, they got a number, but, in his trance, he threw out the receipts as he was talking. "Aw just take down these numbers....you'll get 'em."

They never arrived. Ten days later Anita found them. But the SAA crew lost them a second time.She called J'burg and threatened to have the entire baggage staff over there fired. They found them again, she called calmly.

At 11:30 one night in Connecticut 26 days after I returned home, the doorbell rang. "Miss, are these yours?"

Those preliminary drawings, done in the fields of South Africa, and lost nearly a month, became "Midnight Footprints of the San Artist", "Queen of the Pasture", "Maluti Melange", "Sleeping Ducks at Schaaplaats Farm", "Haunted Hideaway Under the Dinosaur's Paw".

Without Anita Martin, "Birth Mother of Us All-South Africa" would have been without the emotional landscapes that were Pretoria crowd favorites.

South Africa 2001

Archaeologically, I have always had a huge bent in my psyche. Way back when the children were little I read everything available. I even taught a course in biblical archaeology at the First Presbyterian church in Corning, N.Y.: "How Much Fact, How Much Fiction and Folklore in the Bible?"

I created a game, a treasure hunt, for the class: Strolling the Corning Glass museum galleries, which perfume bottle would Jesus' mother recognize? Which glass drink from?

At Cornell University I applied for an archaeological graduate degree, minoring in anthropology. The dean of faculty called to say I was accepted, but advised me not to come.

"They are arguing about you interminably. The anthropology head wants you to major in it. The head of archaeology vice versa. You have done so much work on your own. They would make your life miserable."

That's why I have an MA in Education from Elmira College, keeping the peace but denying myself my first love.

Eventually, maybe now, I am inching toward revenge! Invited to "do for South Africa what you have done for Greece," Ado and Fiona Van Rensburg lured me away from invitations to Paris, Munich and Australia following the September '99 Melina Mercouri show in Hydra. Back then, I did not understand what they meant.

All I am sure of is that I am continually drawn to the unknown, where I am ignorant, as a way of life. This suited my idea of plunging over my academic head. Also, of course, I would be near to Leakey's work, be able to set my foot on Sterkfontein, read the latest, in English, about the newest South African discoveries.

Driving past the first of 7 kilometers of tin shacks, on the road from the Capetown airport, jolted me above ground instead of under. And it was nearly two years of interviews, exploring townships, listening to educators, documenting murders, rapes, burglaries, struggling artisans, fearful shopkeepers, hopeful young, terrified old that I allowed myself to return to my original interest. I had hit the wild, wonderful transitional street that is South Africa, running.

But I always knew I would document, visually, that thanks to the miracle of mitochondrial DNA, we whites have color in us and that blacks have the reverse as well. As usual I did not know how I would do it. I just had to wait.

And 46 paintings later, three round trips plus three days before I was to leave America with the last batch of work, I was still waiting. Opening night was just 5 weeks away. Furious at myself, I could not seem to force this idea out. I had a million ideas. Clichés. I practiced gorillas. I collected dozens of double-faced concepts. All trite. I read books about gorilla life. Children's books. Adult books.

I became so saturated I felt I would spill over in my own head. Drown of over-ideation.

I almost did. The Saturday morning before we flew I went down to the studio and opened the wrapping paper from a large sable brush that Pat Yallup had given me. Costing over $100 in the U.S. I had been so overwhelmed by this stupendous gift 8 years before, that, in reverence, I had never opened it.

Chinese calligraphers use such a brush for large work, as it holds a great deal of ink. And Pat knows I work huge.

Lecturing myself I said, "Look: if you can't turn out a fast Chinese gorilla with this amazing $100 brush to do the work, after all your reading and reading and reading, you had better quit. You are not an artist anyway. You are a fake. This is it!"

Over a year before this I had prepared a bright yellow canvas (to animate an idea that wouldn't, now, come). So, I filled the brush with umber. Dared myself to do a gorilla from memory. Fast. Like the Chinese ancient minimalists, who swooshed out animals with fur in just a few strokes.

I was so scared I swooshed it, put the brush down, and raced upstairs. I actually could not look for three hours. After dinner, I tiptoed down to the studio. It was a gorilla! It gave birth to itself. It just sat there mocking me. Downhill was the process of coloring it half and half and making the apple for its mouth.

The title? "But the Real Question is: How did we all lose our fur?" I named it in 2000, two years before it "appeared."

As a p.s. to this tale, Dr. Francis Thackeray, renowned Transvaal Museum paleontologist, turned the tables on me when he was a featured speaker during the Pretoria Academic exhibition.

"You know that joke Jackie has made out there, how did we lose our fur? Well, that is a very serious scientific mystery these days. We are just now trying to figure this out."

50

University of Massachusetts Hospital 1996. Worcester, Mass. Radio WTAG

Ed has convinced me I have to show up at the radio station. It is a typical Connecticut February blizzard day. At the top of a high, high hill, through many icy city streets, sits a friend of his whom he has promised an interview.

For the Worcester, Massachusetts hospital exhibition they have asked for landscapes, obviously because no one wants to be outdoors this time of year, risking their lives on icy stairs and stranding their cars backwards on snowy slippery hills.

Think summer. And because he has been such a wonderful help, I know I cannot refuse him. But I also know I will blame him when we have the accident, going home so late in the day. It's just a matter of time.

I am in such a bad mood that when his friend asks me, on the air, how I really know what I am going to paint, I reply much too quickly, watching out the snowy window, "Well I never paint anything unless I have to go to the bathroom."

Looking at me in his earphones I will never forget his face.

He looked over at Ed. I glared at Ed. The glare said "That's the truth in a few words. Can we go home now?" Like a child. Trapping all three of us.

The radio audience must have felt the dead air. The interviewer could only ask, too late, "What?"

And then I had to stumble into a description of myself, outdoors with a friend or group, afraid I will be inspired, unexpectedly, as I will immediately need a bathroom or a large bush.

The only person who does not find this tale hilarious is my friend Dr. Rikki Lights.

"Honey, you have the answer! We always wondered why you were different from all the others. You are the real artist. You actually experience a chemical change when you commit yourself. You exude serotonin. Your body floods with it."

Exactly.

Hanging International Shows

What "works" is the key question before any show. I am so tired and bored with myself, by the time I finish what I consider a "collection", I always want to run away.

Not having made them in any order, not having done what one would call a series on one particular subject, I am always the victim of my own spontaneity, my own eclectic and, by now, "old" decisions about what to talk about at this place, at this time.

When I choose the title, in advance, I always make it a broad one. "Staircases, Statements and Sustenance"; "Landscapes My Hand Has Danced-The Tangible Rests Precariously Upon the Untouched and Ungrasped" (John Dewey); "Illinois Roots, Breadbasket of the Heart"; "Birthplace of Us All-South Africa" etc. This allows me to keep my blinders off. To not be specific. Or to be outrageously specific. It's the breadth of the title that matters most. If I had to do an exhibition about one specific subject I would probably decline. You would want me saddled. I can't run in someone else's saddle.

So I arrive with a huge pile of work. There are windows, a selection of doors, air conditioners that drip, walls that seep moisture when it rains, side galleries with no obvious entry-all sorts of aspects demand attention.

If I am lucky, someone on the site is usually assigned to help me. I have had dynamos with a can-do mentality and lunch all ready. I have had a woman who announced she was leaving for a dinner party, in another state, in two hours. I have had a charming pregnant mother, friend of a friend, who disappeared before the truck of paintings arrived at the site.

In South Africa, Ado Van Rensburg found a man to make, overnight, 45 easels in an emergency change of venue. In Wales, Pat Yallup not only hung the whole show with me in her gallery, she made all the frames herself.

1989-2003

But which to hang where is always my main problem. By now I have learned to choose one dominant large thing, that can be seen from the entry, and build around it. Next I consider color, ideation and the corners. Because I have learned it's important to give viewers breathing space between my ideas, I assemble these "breathers" by color and size -portraits and landscapes mostly. Plus usually a joke or two.

As a first trial I will attempt to animate the corner with a breather that is red or in dominant complementary colors. Then I go backwards to the middle of a wall and choose a large dominant second idea piece, that will hold the wall down and give thinkers room to stop. (They do!) I continue to proceed this way as a first run-through. If a wall sometimes "weeps", as in the Hydra Melina Mercouri backside wall, I make sure my least valuable, to me, work goes there and is watched carefully if a heavy rain is due. If I am in a certain militant mood, I will hang a confrontational debate right by the food and flowers, as I did with the piece about smoking in the Greek show. Everyone that entered was ready to go to war with me. Perfect.

Getting down to the last few pieces is always the most difficult. You often find you hold out a piece for later because it is so important to you.

One of my most fascinating experiences was at this point in hanging the Spanish show. Manolo, the gardener, who doesn't speak English, and I were both up on ladders. Kristen, below us, picked up one of the last three works, one of which we were all three fond of.

There was a two minute pause as we all looked back and forth around the huge room.

Manolo, in Spanish, and I, in English, said the identical thing in two languages! Of all 55 works we both concluded the perfect spot. Simultaneously.

In hanging art shows, this kind of spatial, cultural, color agreement is unheard of.

On Hydra, one of the 4 huge dominant paintings was one whose title, "Marie's Four-Corner Oasis," represents an inside joke to all Hydriots. Nearly 800 steps up to the top of the island is a four-corner tiny grocery called Marie's. Four climbing and descending pathways converge in front of her baskets and boxes of peaches, cherries, lettuce, tomatoes, melons, onion, potatoes.

Hers is the only awning for acres of steps in all directions. In 120 degree heat, or when just plain exhausted, everyone lingers under Marie's awning. In pure guilt, some of us buy an ice cream, an orange, some grapes. So I painted the awning, the fruits and vegetables in a large semi-abstract design mostly dedicated to Marie's free shade. I hung it in beautiful light at the end of the exhibition hall so you would have the experience of walking up to it, a mimic of the real life situation on top of the island.

Marie's competitor at port level is a wiley grandfather who sells fresh produce from a tiny closet-like entry way, the fruits and vegetables displayed on four steps below, beside a main walkway. His grandson, age 17 then, and home from school in London, helps him in summer. A full scholarship student, he speaks fluent English and prides himself as a true Greek patriot citizen of this island, which has produced 6 prime ministers for his country.

"Kostas could you possibly find me some bright red and green plastic crates for the front of Marie's painting I did? I want to put some real vegetables in front of the painted ones for the show."

"That wouldn't be right. I'll find some old wood antique ones."

From opening night on, for two weeks, courtesy of Kostas, fresh melons, onions and potatoes sat in front of the painting attracting dozens of local and foreign viewers who learned all about Marie's oasis. When the room filled to bursting the night of Linda Leoussi's piano performance in honor of the collection, Kostas was in the second row in a jacket and white shirt.

He had never been to an art exhibition in his life they told me. Last year he was admitted on full scholarship to a large English University.

Roe vs. Wade (Pendulum of Life)
1976-2003

If there is one idea I have jelled that means the most to me and has proven its international ability to "speak" it is my sculpture, Roe vs. Wade. I chose the name to represent both sides of the legal issue as well as my reverence for life itself. In Europe and China they call it Pendulum of Life.

Among both men and women it retains its original ability to evoke deep emotion.

Where did it come from? I will try to unravel the process here: It arose from my bed at 523 Harbor Road, Southport, Ct. U.S.A.. I was confined with viral encephalitis for many, many weeks. When I stood up to go to the bathroom the room gently swayed with me. When I laid down again, it swayed not quite as distinctly, but enough to let me invent a game, trying to catch the dresser in my right eye before it moved.

My cardiologist doctor, then head of the American Heart Association and a close friend of my parents, told me I just had to ride it out. No antibiotics would help. "And don't be heroic...it's like polio. The people who tried to be super athletic and kept going got the worse paralysis. Stay put. Move as little as possible."

Day after boring day I lay there. I read and reread Watership Down, imagining myself a rabbit in an underground tunnel tribe. This secondary mindset allowed me to completely escape my own. When I found the courage, I assessed what I had to show for my life, if this bedroom turned out to house my Last Chapter.

Four daughters. A mother. How could I represent the idea that being responsible for four human beings had become the anchor of my life, the fulcrum around which everything else had become possible?

How different from when I was hell-bent to be a world class reporter with a Filipino houseboy! In college I spent so much time working for the Syracuse Community Chest, organizing the first Annual Public Relations Conference between the university and 550 local organizations, among many other jobs and my course work, that I didn't even have time to wash my longish hair. I sent to Macy's for a good dry shampoo. Every minute counted toward my future goal. I won the prizes, was Phi Beta Kappa my junior year and was too embarrassed and busy to even go to the meeting.

A mother. I was just a mother now. Maybe dying. But I felt more crucial than I ever dreamed possible. Four products. I had made the brains for four incredible human beings. Had sparked their minds, tossed them into the madness of this life with a can-do mentality, a journalist's "find your own information "way of life.

Why did my American culture not consider this the finest job available? Could I con-
front this in clay? Could I show myself a catalyst? Could I get across the feeling these children become
the pendulum of our lives and actually grow US?

Day after day I made it. And unmade it. In my head. In the very beginning it was
a dinosaur shape with notches. I closed my eyes one afternoon and wiped out the notches.
Too obvious. Motherhood has been going on since the beginning of time. Why try that
approach? Why say anything at all, if you get to the bottom of the concept? It's too basic a
subject.

But why not?
I had to show the impending baby as a pendulum. If it was too big it would break the arch.
Where would I appear? Should I appear? Nowhere. Or maybe somewhere very small. In wonder at
what I had created? Or maybe not. My four creations were really creating me, wasn't that the bigger
point?

If I died now, they at least will be able to see how I felt about them. They
maybe will touch it and say "Here's mother talking about what it was like for her,
bringing us into the world..."

I should be there. Somewhere. Slowly, I envisioned myself at the front of the arc,
grounded, a tiny head representing my diminished self as a mere temporary carrier for four
important new beings. How?

I would coil my hair around my head Swedish style, symbolic of my
ancestry, and in memory of my hell-bent career past, when I bought only dry shampoo.
Breasts? Stylized: at Stage One sex and children go in opposite directions.

Slowly each day, in my head, the form solidified, adjusted in proportion to the idea. It began to make me quite happy. I began to see I could make something meaningful to show for my weeks alone, contemplating my life with my babies. And even if I now had to leave them, never be able to celebrate or nourish their lives further, there would be this "something." I determined to give my last energies to drawing it, so someone else could make it in clay one dull afternoon. If I died.

I didn't. And I made it myself. In one dull afternoon.

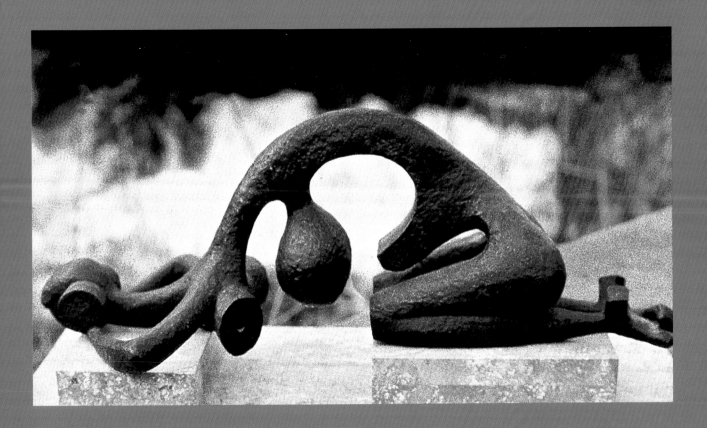

Years later, speaking to a large group of young adult art students at a museum exhibition of my work in Illinois, I glanced over at Roe vs. Wade on its pedestal. My eyes filled with tears in the middle of the talk. I had to explain. I had just re- recognized the reverse space, behind the pendulum, that I carved out to represent the spirit of the unborn child-to-be. I had completely forgotten about that space, planned in bed so long ago, fighting uphill against an encephalitic nightmare.

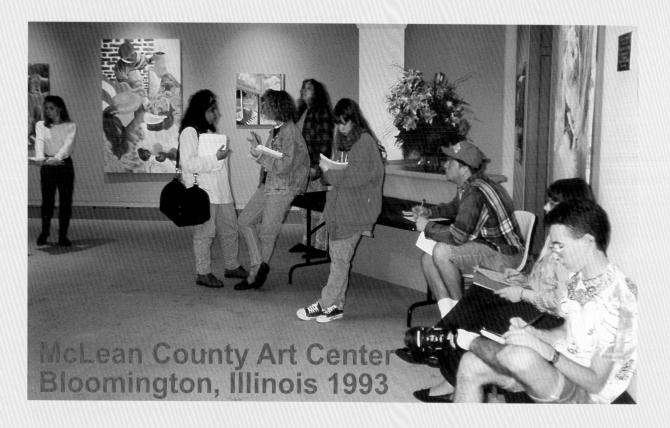

McLean County Art Center
Bloomington, Illinois 1993

When I look back over the catalog of the McLean County Art Center one woman show, it stimulates a plethora of mixed memories.

By now 22 paintings in this show have earned a decent reputation for themselves: one is in a library; one has become a Christmas card; one is now the cover of a music CD by famous international women musicians; one was destroyed by UPS enroute to a collector; two are the subject of limited edition heavy silk scarves, hand-painted in China; two are the genesis of a collection of male nudes.

I learned so much in Bloomington about myself, and about exhibitions, that the lessons travel with me all over the world today. Fourteen years later, the lessons mean much more than the modest success of the collection.

First of all, the curator's statement was the first professional mirror of myself to which I had ever been introduced:..." "I feel this is a rare opportunity to view works of an artist who paints with her emotions, and who is not caught up in what may or may not sell. Each work is a small insight into a facet of Jackie. This personal exposure of an artist is something we rarely have an opportunity to experience..."

A fellow Midwesterner, he saw right through me. Rightfully, he predicted my world today: I still have no idea what will sell and I can not seem to train myself to focus on that. I don't enter competitions. Art, for me, has nothing to do with competing. Because this show was a mere 20 or so miles from my hometown of Washington, Illinois (he had discovered my work at Art Expo in NYC and found out I was from Illinois only when he invited me!) I pulled out all the stops of my subconscious: I would paint my world, their world, and everything in between that I thought they would enjoy.

"Living the Weather or Not Life" is a reversible farm landscape giving farmers a double sky, a double chance to get the right weather to plump the corn; "Something From Nothing" burst from my 8 year old prairie childhood depression: how would I ever make a living, be able to buy books, a house, grass, a bed? "Spring Architecture on Southport Harbor" spoofs my present home, where yuppies compete with formal landscaping, decimating the natural wildness of the riverside.

The historic rains of 1993 were violent, destroying the idyllic independent serenity of the typical Illinois farm citizens, forcing everyone to band together to save their neighborhoods and land. The triptych "Summer of Illinois '93", tried to show sympathy about that nightmare, during which I offered to cancel the show. They said thank you, but no.

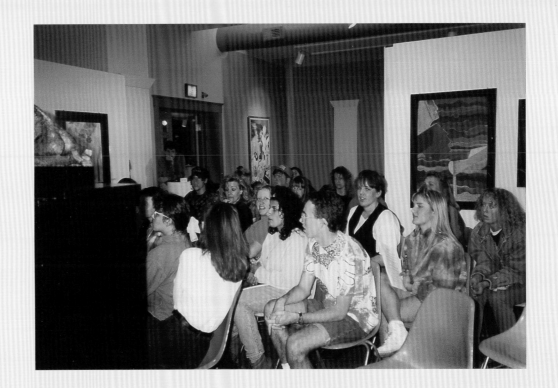

"Caterpillar Man" shows a symbolic abstract tractor driver presiding over rivers of colored soil, representing my father's work as a founder of the first Caterpillar foundries, makers of one of the first international American products, in Peoria.

Having been born in Michigan, I motorized a huge square canvas called "Lake Michigan Forever", replicating the superfine silica summer childhood I prize.

Sadly for me, not many people came. No one bought a painting. There was no article in the local paper. The invitation to the opening, sent out to all my childhood friends nearby, arrived days after the event.

The director of the local zoo bought Roe vs. Wade and would have purchased a large knife painting of an elephant, except I had painted him with his feet in salt water at the edge of a forest. "Elephants suffer with salt water on their feet," he advised me, underlining for me that I had definitely not done my homework.

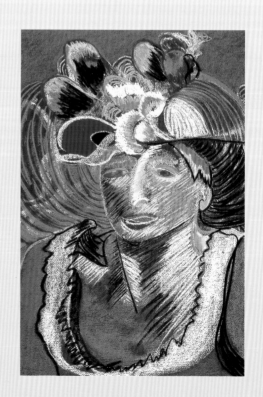

Promising me four sculptures of Roe vs. Wade "for each of your daughters", which he would cast at a local foundry himself, I gave the curator $800. I never received them. He resigned from the museum. I donated a large painting about the food chain.

The most insightful thing I learned was from the museum manager, a woman about 28 years old:

"Jackie I just love all your work."

"I'm so complimented. I know you see so much great work from so many other artists."

"Sincerely. I love it."

"But which one would you really prefer? They're so, so different. I couldn't pick one myself".

"Don't laugh?"

"No."

"The male nude. I'd put him right over my bedroom mantle."

She proved to me forever that you cannot rely on what you read. Especially about art. Somewhere, way back when I was a writer, I read that the most popular painting subjects through the ages have always been women, flowers, children, landscapes, animals, still lifes. Last on everyone's list: men. I've been determined ever since to have a male nude in every show. I love them myself.

International Sales 1989-2003

I have never sold any of my paintings about contemporary affairs in Greece, London, Spain or South Africa. But they are all favorites with the crowds. If I were sensible I would not make them any more. But I am not. And I have learned to keep the prices of these "conversations" high, as I enjoy them more each day myself.

The reason? They provide me such fascinating responses: arguments, smiles, confrontations, sly awe that I dare confront such a topic. They seem to arouse a continual momentum in the general public, who by now feel free to ask me to paint about all sorts of subjects that matter to them.

They don't want to buy the work. They want to look at the problem. Just like I do, perhaps.

On the fax machine three months before the Welsh show, came a request to talk about the hired wood cutters in Queen Elizabeth's Forest of Dean, sawing down the redwoods for quick cash. How else could I know how she got her pocket money? When I recovered from the idea of this first "request", I did a long two foot by five foot painting which still hangs beside my bed in my Spanish apartment, on the island of Majorca. Luckily, I love it.

When I painted an elaborate joke about the Greek Orthodox Church offering a monthly stipend for third babies-"Free Monthly Pension, Including Angel"-a prominent architect and his wife got into a delicious discussion in front of it. She said, "Why didn't you tell me?" I thought the poor would find it informative. That the professionals would jump on the bandwagon of free babies never occurred to me.

At the same show a Canadian geologist visiting Hydra wondered, in my guest book, why I hadn't done something about global warming? Next time maybe.

Closing down the South African collection last November, Joan Burton asked, "By the way, when you come back for the reopening will you bring something about AIDS?"

As an interesting aside to all this, at the Greek show the owner of a Parisian gallery for over 30 years sat down and took my hand: "My dear girl, did anyone ever tell you that in all the history of art no one but you, that I know of, has done an elaborate beautiful painting that turns out to be an elaborate joke!"

There's something about an expectancy factor in all this that fascinates me. If people think I can do it, maybe I can. It's more important than money to me, to know I have done enough work, about enough issues, that I can be trusted to lock myself up and speak, in paint and pastel, about what matters. To them.

On the other hand, posterity-wise, as Beth Noble my portrait painter friend once advised me, "You know it's not art that lasts, stuff like that. Universal things are better. We have to think about the long run."

I did. The short run is o.k. with me. If it gets people to laugh or gets people thinking from isness to oughtness.

Wales 1994
Pat Yallup's Gallery
Summer Solstice, Llandogo

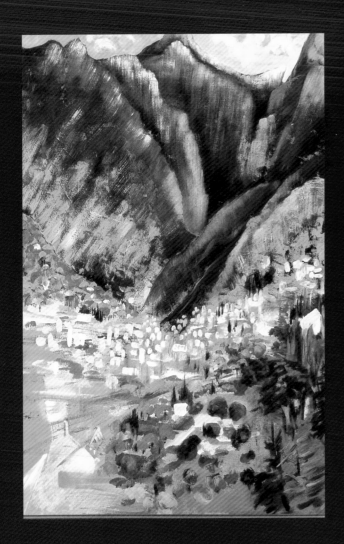

Pat Yallup's Llandogo, Wales gallery is down the road from Tintern Abbey. All my other shows had been in huge public spaces or municipal juried spaces.

Pat and I met at Art Expo in 1992. We had adjoining displays and neither of us sold much but my Roe vs. Wade sculpture lured many thousands to the Jacob Javits center in New York City. As a result I was invited to do the one-woman show at the McLean County Art Center in Bloomington, Illinois.

The following year Pat asked if I wouldn't like to come over, visit her little village, and consider an exhibition in her gallery. With my daughter Merrill in Wimbledon I was very excited to spend time with both she and Pat. My adventures with both of them that year are very precious memories to me. Pat's generosity, hauling me back and forth from London, out into the fields in downpours to do landscapes, tucking me into a special bed she devised right in the middle of the gallery space, is as high a standard of friendship as I ever expect to receive.

Our mutual adventures could fill a small hilarious book. But the one that lingers is summer solstice evening. Pat had, by then, taken me to Chepstow Castle near Lord Nelson's home, so I could interpret, in my style, a real castle on the lip of the roaring Wye river...she had driven me to the courtyard of the ancient 17th century church from which religious zealots set out for their medieval pilgrimage to Santiago de Compostela. And one morning she took me to a very, very high rock formation in the distant countryside.

"This is where they murdered the virgins."

"They what?"

"The druids dressed them up in long white dresses, tied with ribbons, and lead them up in a procession to the precipice, where they were thrown off as sacrifices."

She was so matter of fact about this local history that I took a big proverbial gulp. I decided if it was such common lore it would bore the locals to paint about it. But one day I would research all I could discover on this subject, as it would definitely fit in with another exhibition I had in mind.

About two weeks later I noticed yellow police ribbons strung for hundreds of yards around some of the area farmlands.

"Oh that's because the summer solstice is Saturday and there are lots of wild young gangs that gather around here at any place there is an ancient stone, like Stonehenge, on the property...It's a big, big cult around here.."

"Violent?"

"Can be. Very."

Saturday morning, about 10 our phone rang. Pat was at least 10 minutes telling someone "Don't worry. I'll warn everyone I can."

"The vicar's wife..."

"What does she want?"

"She wants me to call people to be prepared for a lot of trouble. She's heard there's a huge crowd coming from all over, even London. Anything can happen."

"Is she concerned for some reason?"

"Nothing, really. She's just over-excited I think."

After supper that night, 9ish I think, I said "Pat, we can't miss this. Let's drive around and see what we can see."

"It could be very dangerous... And I don't want anyone to see me and think I'm one of them."

"Well if we see anyone, you know, you can just duck low in the car and turn around."

She couldn't resist, with me nudging her. And it was light. So light out.

We drove past ribboned -off farms with police vans sprinkled along the roads. Caravans with battered paint hulked here and there.

Suddenly we rounded the corner into a tiny steepled village. Almost a block away, we could see a procession coming toward us. Pat angled the car with our backside to the group, so we could dash.

Looking backward, we saw 5 or 6 men in drab brown hooded Druid cloaks carrying crosses, with three blond virgins in white between them, their bosoms crossed by long blue ribbons. Behind, a gigantic crowd of hippies, leather, long skirts, wild hair.

Fascinated, we slunk lower and lower into our seats. And then a gasp! "My God, Jackie, It's my vicar!"

Back home 6 months later in my studio, I found photographs of a large mysterious over-hanging rock that I had taken in Menorca. I knew it would be the perfect jumping-off point for me to paint about that shocking night.

In murky brown and green ochre colors I did the procession from memory. On opening night in Llandogo, the head of the historical society of Pat's region never left his place at the wall, beside where this tiny sum-mer solstice painting told the story.

My invitation to speak to his Welsh historical society was a challenge and a joy. It pushed me deeper into studying medieval mindsets. And vicars, 20th century.

Durban, South Africa 2001

Bifurcation is a word I thought I would never use. But there is one painting I have done that will always remind me of a bifurcated moment no one could ever forget.

Saturated with my research all over South Africa, I always knew I would want to make a painting about the overall mentality of the new black government. Unused to power and dedicated to representing all the people with consensus management-11 languages and hundreds of ancient tribal customs to deal with-is no easy assignment. Earlier, the multimillion dollar education budget had been turned back for lack of an agreement as to how to use it best.

One Saturday morning, as I was pondering how to paint about this, I went into an Indian pharmacy to buy more Lemon Lite, an amazing cool lemony face cream that I had discovered in Capetown the spring before.

While looking about for it, I glanced out the window and saw, at this mall end, a chess game going on outside with huge high pieces just beyond the entrance door. A dozen black men of all ages were anchored about the set in various positions and the pieces, white, split into my brain like bullets: the painting was just outside the door.!

In a rush now, I turned around and asked the girl for the cream. "We don't have it I don't think...what's the name?"

"I don't remember really."

got down on my knees and searched across the lowest shelf. There it was: Lemon Life Complexion Cream With Real Lemon. Made by Adcock Ingram, Isardo 1600. SA.

"Here it is", as I dug for the rand.

"I'm not going to sell that to you."

"What do you mean?"

"I won't give it to you."

"Well why are you in business then? Are you the owner?"

"No." And she walked away.

Ed hunched his shoulders. Raised his eyebrows. I was furious. I desperately wanted to get out of there and look over the chess game in detail, but at the same time I was determined to get that cream.

I followed her across the store. "Where is your manager? Are you alone here?"

"No, but I won't sell it to you."

"Why not?"

"Because I know what you're going to do with it."

"What will I do?"

"You'll give it to your maid to lighten her face."

Every time I look at my huge 6 foot leathery "21st Century Chess Game-Durban" - representing thousands of hours of studio work - I am right back in that Indian pharmacy trying to buy the cream that made South African "upward mobility" a two dollar possibility for all.

Therefore, I will keep going. I now have proof that a stranger in paradise can uncover secret longings on the bottom shelf of a drugstore.

And I have the comfort of knowing, for my girls' sake, that I at least look well enough to be suspected of having a maid! My childhood dream was to become a world class reporter with a Filipino houseboy. Somehow, I've become an artist who is suspected of having help. Maybe, I'm at least on the right road.

In Durban I first recognized, with the South African collection, "Birth Mother of Us All," that I must have been concocting, for each country, a specific recipe of drawings and paintings for many years. In a certain sequence, they seem to exude visual rhythm that speaks a larger language to the viewer.

The old adage, greater than the sum of parts, usually appears- a hidden equation that viewers tell me occurs in my work. I must by now expect myself to pay more attention to sharing that equation and specifying a required sequence with the many people who help me hang the shows. I.e. each collection represents an intrinsic algebra, when hung with the viewers' experience, cumulatively, in mind.

I had long recognized that I assign myself certain categories to consider when accepting an exhibition where I intend to exemplify an overall journalart collection. That's probably why I often work on seven or eight paintings at a time, once I get going. It's as though not any one of them is any more important than the other. I am never "making a painting." I am assembling a lot of things to talk about. Each one of them is saying something I think is interesting or insightful, so I don't hang too heavy in any direction until each work, by itself, begins to plead with me to face up to the responsibility of perfecting it for the eyes of a stranger. What I have begun is essentially an experiment for myself: to see if I can get this idea going some way.

I clearly always have to deal with the fact that, embedded subliminally in the minds of the viewers, is a literary river I need to swim in. I read and read and read, like a journalist with a deadline. And an editor. I know I need to seriously swim in their poetry, short stories. I need to feel comfortable with the images, symbols, expressions, slang that specifically evoke that region or country. Newspapers, magazines, T.V. references blend in with my homework. Then there are universals I want to strive for ...concepts like "Something From Nothing": how the uneducated, poor, troubled, optimistic commit to a way forward.

Fate circles the lives of each person in every culture. John Donne's concept, "Thou Art Slave to Fate, Chance, Kings and Desperate Men," is always visible in action in every country in which I choose to work. The common person's longing to become, undercut with the angst of futility....the newly secure person's guilt...the overly secure person's boredom...the aged succumbing to the policies of the state, as well as the cultural impulsiveness of the young.

For me, it is like a play winking to be captured and painted. Fascinating, it is so easy to taste how much each culture shares when you look deeply. The commonality of human life on the planet lacks only the re-sprinkling of money, re-sortment of geography, control of the wind and sea and a composite deity in which each person owns a share!

But in the long meantime I can only begin by offering a mix: First, regional gestural casual landscapes. Swift local portraits that hopefully give back a mirror that life in this particular place is unique and fascinating to a wandering stranger. Actually I choose each region for its authentic allure to me personally. In landscapes and portraits I think I try to certify that authenticity with the free and wildest possible use of risky experimental color and design. This is my way of celebration, and in no way do I tend to take all this too seriously. The paintings sort of happen out of the joy of the choosing in the first place.

(Interestingly enough it is at this stage that I often spring forth with a face of someone I have been thinking about without knowing I am actually painting them! This stage of work is so joyful and offhand that I seem to unwittingly sometimes shift into automatic and other people's faces come through my hand while I am on the road to my REAL project.)

Always, in the back of my mind, while I am working on these kinds of things, I am focused on what for me is the larger job: What will their futures hold? How can I project this in the next canvas? How can I join them in thinking ahead, as a mere fellow human, about what to expect, plan for, be way of? Do I sense signs of change? Ominous? Predictable? Joyous? Can I risk transmitting? Should I transmit? How to transmit?

Usually this is the harder part. Presumption is the little bird on my shoulder that I must constantly re-shoot. Will they take offense? Will they go to work in this new direction? Will they fault me as a meddling outsider? Will they experience a new "aha!" Roll their eyeballs and scoff "mad!"

It's all conjecture on my part, this journalart. A willingness to make a fool of myself. A willingness to be shot at. A willingness to be appreciated and taken in from my journalist's street as a crippled imposter painter-just one hopeful and hopeless human.

"Black Moon Rising", in the South African Collection, is one of those conjectures. The devotion to one's ancestral land, re-claimed, and at the same time the often casual disinterest in the rising power of the black political "moon" that must now re-arrange South African tribal affairs in all directions.

"Bonjani Switches to Fly Casting" in that same collection offers a bit of a clue to South African mobility: the abandonment of bread and mealies as bait, in preference for a purchased imitation of nature.

"Planetary Menu, Limited Time" warns even your language will be re-evaluated, among thousands of others, according to its economic usefulness.

Of course I never know in advance what the reaction will be. And there have always been plenty of surprises, both ways. Some like what they see. Some are frightened by the prospect of the message. They go home. Others consider a concept for several minutes and put down serious money. I can never be sure what the journalart response will be. I can just conjecture and hope that what I am doing opens new arenas for thinking. Or conferring. Or at least portrays the bones of the skeleton of hurdles we all face continually.

What I am sure of is that these types of futuristic and conjectural works need to be "cushioned" in hanging an exhibition on the wall, between the portraits, landscapes and literary contemporary references.

They smoke.

And I learned in Durban, South Africa I need to now step in and help with the exact placement of each painting, to be sure that smoke does not get in your eyes.

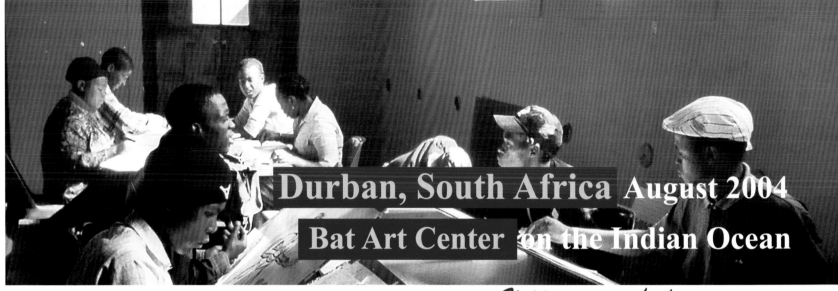

Durban, South Africa August 2004
Bat Art Center on the Indian Ocean

Hidden vector: thinking versus seeing

"I hear you're an artist...I don't really know much about art." Me, either. Many people say this to me and I think it's because they think there is some magic rule, invisible to them, by which I will surely secretly measure their taste if they try to open the subject with me.

If I try to explain I do not consider myself an artist but a journalist in disguise, it does not help. It confirms. If only there were some quick way to express that, if one is not intellectually meshed into a

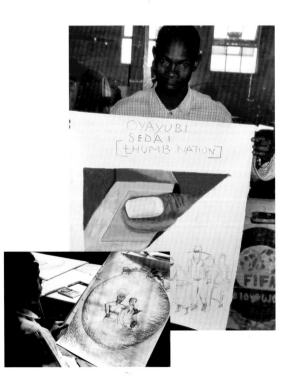

work of art, it is not "art" on your terms. At best, it is a pleasurable, visual handshake soon forgotten.

There are so many artists with dazzling technical skills that most people are afraid to say out loud that the work does not melt into their own consciousness as a valued experience. "Great to look at!"... "Far beyond anything I could ever attempt"... etc.

But when one gets into bed at night seldom does a painting or sculpture climb in and run around the pillow with you. That's what most of us long for, but that's what we very seldom get. How do you make an idea that climbs into someone's bed?

Given 25 Zulu men and two girls, ages 18-35, students at the BAT Art Center in Durban, South Africa, August, 2004, who were mostly unemployed, gifted and with some skills training, I was determined to prove they could do precisely that.

My collection for South Africa, "Birth Mother of Us All," was hanging in the Durban Institute of Technology galleries and Reggi Letsatsi, the curator, together with Christopher Randelholf, Arts, Culture and Tourism staff of Kwa Zulu Natal Province, had arranged for me to do three " Paint Your Life" workshops with this hip art crowd. BAT provided huge slabs of cheap paper, support boards, tape, crayons and pastels, spray paint...all necessary materials to net rapidly flying ideas.

Beforehand, I made sure no one was given the collection catalog. My whole purpose was to prove to each one they could easily create catalogs of their own Durban, South Africa township lives, by training themselves to look inwards, risk failure, fish happily for what would "bite"-their own memories and day to day experiences, where every other person on the streets outside BAT is carrying a gun.

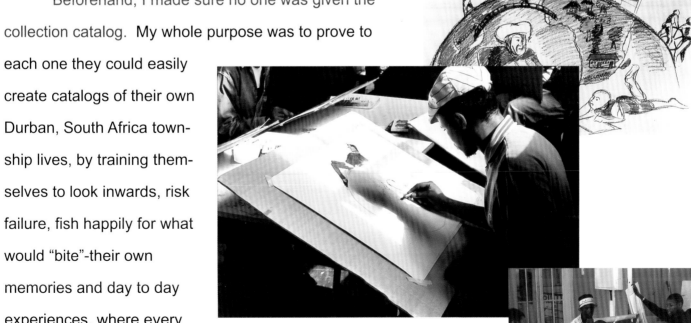

Once again, in this new raw arena, the 14-20 minute "Paint Your Life" sequential games I had created years earlier, to inspire professional English, Spanish, American artists (beyond their own boredom and derivative concepts) into the random arena of un-recovered experiences, proved their worth.

For three mornings I had the penultimate joy of attempting to preside over 25 leaping artistic brains, scrambling under a time clock, to drill into the interior of their remembered experiences the veins of gold entrenched within their apartheid selves.

They spoof the perilousness of art by creating envelopes to be sent off into the rain via the unpredictable African postal system with its haphazard stamping machines. They split images. Compose pictures of each other from raw spontaneous interview words. Draw themselves getting out of bed and walking about on an earth filled with the ashes of people they loved, lost, and live in memory of.

Assigned insignias for their generation, and for a new international organization, they dance rapidly about with concepts they had never known or considered, but which dig new trenches into their own experience.

Their "aha" was palpable. Both to Nonnie Uakalisa, the director, and Njabulo the summer curator, as well. Still is, as the BAT artists continue with me by e-mail and post.

Before, they had mostly only painted what their eyes saw. And of course the design arrangement of images was typically South African. Now they fully recognize they are "transmitting Africans"... able to talk to viewers with a complexity of concepts that have the same African flavor but about the ideas that embed deeply in the minds of their viewers. So deeply that the response to their work is almost difficult for them to learn to handle.

They learned people don't walk by their work. They stop. They think. They see a whole Fulbright committee walk in and do just that, when we hung up a few things with clips one morning.

Most of the guys did not even look up though. There were more things in there that they were busy taking out. They are already on a lifelong hunt.

Tony Zhicong Li

China: 2001 and 2004
Shanghai and Shenzhen

I was scolded like a child this September' 04 in Shanghai.

China is a delicious dichotomy for artists: super energy, hand skills, smiling Chinese faces and a can-do-it-yesterday mentality surround you the minute you step from the plane. It's in the air. You literally want to jump in and produce with them or at least sign them up on your team.

On the other hand, if you have a true friend, who is Chinese, he'll show you around Fake Street in Shanghai, where anything and everything ends up reproduced, price-reduced, all ridiculously quickly. With the same smile.

If you're fearful of being copied, your intellectual brakes will spoil your trip. But if you're grateful you may have done something worth copying this will accelerate your desire to become part of this amazing energy that spins from the thousands of bicycle wheels zipping by and hundreds of cranes overhead layering up speculative skyscraper apartments for the un-arrived.

There is an atmosphere of "now" and when the bicycles disappear it will become a big "now what?" for the entire planet. It's in the air already in 2004 and my second trip this September meshed me into that momentum instantly at Pudong airport.

Where else will you find almost an hour of red and green precision-trimmed shrubbery ushering you into a downtown? Your sense of complimentary colors is winked at for miles and miles into Shanghai. (Having in May 2001 had the personalized care in a Shenzhen hospital for an ear infection and swollen face, courtesy of the sap of a camphor tree hugged in an emperor's garden, the 60 miles of landscape exudes the same Chinese spirit: we care. You are our guest and you will pay almost nothing for allergy pills, antibiotics, all you need to be happily back in your hotel, a recovered honored guest of China.)

Mao left one good thing: the learned love of each Chinese for the other. Despite all, this communal oneness is a sticky glue that becomes obvious to we outsiders and extends to us if we exemplify true friendship. The current government dictum that "each of we billions of Chinese now have to get rich to develop our country together" becomes a shared joke. They are learning to enjoy this assignment-this push for money instead of rice, but in no way are they abandoning six course meals, live fish and fowl markets, ancestral customs like spring clean-up of the graves. They still bring fresh food to the long departed.

That's why, when they chastised me at the big rainy Saturday lunch in the Shanghai suburbs near Ho Jnling's 5th floor walk-up company Shanghai Jie Juan Handcraft Ltd-that I felt like one of the family being scolded and shamed, though beloved.

After five years of shipping hand-painted silk, limited edition interpretations of my paintings- horizontals adapted into verticals and verticals vice versa on 36" squares of heaviest silk, Peter (Ge Jun Hua) arranged for me to meet Ho at his factory workshop, a 35 minute taxi ride into the Jan Pu district suburb.

By the fifth set of dirty ancient stairs I was braced for most anything. I knew he had 22 employees. It was Saturday. There was probably no one else here. Where would they have lunch? How could there be any "art" in this kind of surroundings?

The fifth floor door opened onto a runway nearly a city block long. White tiles form the walkway for the ten people hand-painting taupe silk scarves, uncut and stretched on suspension rods the length of the walkway under strong fluorescent lights.

To the left, a spotless cutting room with giant bolts of silk.
Then a professional showroom next door with hundreds of scarf designs, hand-painted shirts, kaftans, dresses, lingerie. Tea ready for all of us. Soft sofa, glass coffee table. Such a surprise retreat-an artists' playhouse hidden in the most improbable location.

Ho Jinling, the owner, and his office manager, Chen Jie, seated us on the sofa and we looked at each other in the flesh for the first time in all these years. She has her black hair tied into a ponytail and her round face, with whimsical, flashing eyes, is full of adventure and surprises. Under her yellow and black smock one suspects very daring and imaginative clothing. And she raises her eyebrows so spontaneously when she smiles, I know she is fun. Ho is shy, 40ish , with soft luminous brown agate eyes, receding hairline. He does not speak English but one can tell he is disinclined to talk a great deal, even in his own language. Very modest, very, very happy to meet me and in no rush to talk business.

He asks Peter to explain to me that he always wanted to be an artist. He copies each one of my scarves by himself: He mixes all the special colors himself. He cannot trust anyone else. But also this makes him feel like he is an artist.

Humbled, I find it hard to reply. I never had envisioned another human being on the other side of the planet trying to be me. And such a terrible task I must be for him, as I do not know what I am doing, myself, most of the time. The layers and layers of pastels, the hundreds of mistakes I make and cover up... the lines left unfinished that go nowhere... the thickness of the lines... the thinness... It's too much of a nightmare for me to think about head-on. I could never, ever, follow me. It is too hard to BE me!

So I change the subject. I tell him I can see his company does many hand-painting projects, working with many artists. I inspect over 300 scarf patterns on all kinds of fabrics and the individual pieces of clothing. Nothing looks like my work. On the one hand I am relieved. On the other, heartsick for him, that he has found me worth following. And for nearly five years has assigned himself this terrible task.

We measure Chen Jie to the ankles, planning to order a first sample silk sari out of a bit longer piece of silk. Ho turns on the computer and shows me my designs. Obviously, he is proud of his work and very happy to have us here on his fifth floor hideaway, where he can actually be with this American artist he has been "living with" for so long.

As it is now noon, he announces that he has ordered all of us lunch at a neighborhood restaurant. The three of us under umbrellas, in heavy rain, make a two-block dash. Ho leads the way, without umbrella, across two streets into a cozy local spot with tiny one-table balcony for private business guests like us.

Dumplings, fish, rice, vegetables, soup, shrimp, pork ribs stream endlessly from the downstairs kitchen, with the serving girls staring at my white hair, wondering if I would use chopsticks. Ed, sampling local beer with Ho and Peter, and showing no signs of his usual trepidation, is totally happy and enjoying himself, not having to talk at all under these Chinese circumstances.

Then it happened. Ho leaned over and seriously conferred with Peter in Chinese. Chen Jie nods, then nods again at them. Peter looks at me, then looks away for a minute. Talks to Ho again and then clears his throat.

"Jackie, he would like to talk about you and him. He thinks there must be a big difference between Chinese and American people."

"Really? What are the differences he sees?"

"Well, he thinks you don't understand."

"Understand what?"

Peter now is struggling. I know well that Chinese people, if they have something to say that is negative or they think will upset you, will deflect a reply or be silent.

Peter looks painfully at Ho. And then at his plate of empty shrimp casings.

"Well, Ho says, Chinese people when they are number one are always rich and famous. American people he thinks must not understand this."

I don't quite understand now what I am supposed to reply.

"Well, Jackie, he says to tell you, you are number one painter. That is why he does all your scarves by himself. Why do you not give him big orders? Your work should be big orders. You should be famous Jackie. In China, if you are number one and not rich and famous, Chinese people look down on you. Something wrong. He knows many Chinese silk painters. You are the best."

Now I am in shock. I realize they are truly friends or the would not be so forthright. I do not know what to say. I just look at them both, their heads down now, in shame for being so honest. And how can Ho ever want to paint even one more of my things? the colors so wild and the patterns indiscernible to even me.

All I can think of, and Ed not reacting in any way to help me, "Well you know me, Peter. All these years, Did I ever say I want to be rich? Nobody knows me really. And just making money?? I started doing this because I had made money and so what? It didn't make my life easier and I was not content. Now I am really happy. Breaking even, helping people to start businesses all over the world...having lunches in Shanghai with three people like you"...I trailed off.

They obviously did not like my answer. They looked at each other. A true cultural impasse. And I was the impasse! Ho looked straight across at me, while Peter translated.

"Please tell Jackie if she does not want to be rich and famous Ho does. He has a young family and, through you, they could be rich and famous." Chen Jie, smoking a cigarette, nods vigorously.

There was no answer to this. I am a true failure in their eyes. I am only thinking of myself, not others. I am happy and content at their expense. I need to have a cultural screw loosened in my head and a re-dial installed. There has been a call waiting that I have not recognized with American eyes.

Gently they smile at me. Gently I apologize and promise I will return home and focus on orders. How to keep my privacy, avoid commercialization of my ideas, escape planetary exposure, while acquiring planetary orders becomes a 2004-5 lunch table challenge.

In the midst of this austere moment of truth, one of the cooks climbs the four stairs, opens a tiny cabinet door to a shelf in our balcony wall, pops himself in and pulls it shut!

Everyone laughs. "His rest hour nap," Peter explains.

SHENZHEN 2004 AND 2005

Ho and Jackie Chasing the Wind

Ever since the waiter popped into his wall cupboard beside me for a nap that rainy September Saturday, I began wearing Ho Jinling's head all around Shanghai.

So on this second round of looking at Chinese museums, I decided I must plan to drag Ho into the limelight with me. I decided I wouldn't accept a museum show unless I could combine my journalart works for China with interspersed framings of his silk interpretations. If I couldn't afford to ship the original paintings from South Africa, Greece, Spain or America, I would have colored photomontages made to hang beneath them, showing viewers the true spatially-imaginative handwork of my shy challenger silk painter interpreter.

Peter told me that Ho once told him "painting Jackie's work is like chasing the wind." So when we search for a government or other sponsor I will begin calling our exhibition "Ho and Jackie Chasing the Wind." The more I mull this idea, the more I like it with so many millions of Chinese producing goods for worldwide markets with little individual credit (famous labels usually concealing the skilled artisans making the product) . I could take Ho into the public arena as step one in making him famous among his peers, appreciated and hopefully, eventually, wealthy.

So I looked at the Liu Hai Su Museum with a Chinese American double set of eyes. Their invitation was generous: catalog, T.V., radio, newspaper ads, opening dinner, ribbon-cutting ceremony, speakers etc. Sponsors would pay $15,000.

But Liu Hai Su is in the Shanghai suburbs. Little foot traffic. Ho himself could not get there on a bicycle easily or encourage his friends to come, as I could see no restaurants for a pleasant evening experience in the area. The space? Not ideal for such a huge venture. So I thanked them very much- curators Zhang Picheng and Ma Chu Huaó-and especially Mr. Fan San, head of the folklore collection at the gorgeous new Shanghai Art Museum, who initially invited me to come and have a look.

At the recommendation of editor Zhao Juan-(Kathy) and Da Ding Jiu, of the Shang-
hai Peoples Fine Art Publishing Company on Chang Le Road, Peter took me to look at the
Shanghai Library's new chrome and glass exhibition hall and galleries. A library? I would never
have realized it. On Huaihai Zong Rd. is the most gorgeous new professional exhibition hall
adjacent to the new library. It has a magnificent presence and elaborate atrium entry all its own.
As we walked up the stairs to the glamorous hall, done up with red banners and stanchions of
red flowers, hundreds of press cameras flashed. We had stumbled into the opening of a huge
collection of Chinese waterfront landscapes, painted by a local civic political leader. But, one half
hour later, hundreds of guests had vanished! Sun You Li, the director who is also an art
professor, explained the crowd had come to pay their official "dues."

Space-wise I could see Ho and I here. There were vista views, pockets of cozy
intimate spaces, elaborate soft lighting, an intimate but very large feeling, yet, almost cozy. Li told
me she was sure the young university students she teaches would love my "Paint Your Life"
workshops. I had showed her the photos of the Zulu BAT crowd in Durban last month, pouring out
ideas spontaneously onto huge sheets of crude paper. Transmitting ideas here would be a novelty
for the young of Shanghai.

After that we explored the old Shanghai Art
Museum, a former bank in the center of town-
McDonald's and an exquisite Marriott down the street,
art galleries, shops, restaurants all around. Here were
40 ten-foot exhibition bays, extending six feet deep on
each side; gigantic entry space; big inviting gift and
bookshop. There was an exhibit- Design 2004 and
dozens of young people strolled about with notebooks,
cameras, giving it an air of Action Central.

Peter, Ed, and I agreed: we by now had a good feel of Where. Getting a sponsor on board-possibly the government- is the next task. My goal: to see Ho Jinling smiling beneath huge framed displays of his scarves, shaking hands shyly with his many friends, whom I know will be delighted to celebrate him in a museum setting. It's funny how making someone else happy can give you courage, ideas and energy. I think that is the best thing the concept of journalart

Ge Jun Hua, Hou Jinling, Chen Jie

has meant for me-feeling artistically safe to explore the idea world and to find others to join me who have the same spirit and desire to form a new art internationalism, without the impediment of misleading words and with the joy of creating contact.

Speaking of making someone else happy, Peter-Ge Jun Hua certainly did that for me on this second insightful trip to China. Only just before I left the airport for home did he tell me he had biked all over Shanghai before I came, interviewing all these people he had introduced me to, surveying all by himself all the possible sites for my exhibition just in case the Liu Hai Su invitation was not the best choice for my work!

When I couldn't find large scale rims for my prescription glasses, he found an antique shop with old large-scale frames: $12.

Cashmere sweater for a London grandson's graduation present? He had already told Gao Hui of the China Inner Mongolia Cavavry Textile Co. about me. By the time we appeared she had not only the perfect bluejean-colored cable sweater, but had volunteered to find a sponsor.

"Peter, why are we going to the Experimental Shanghai Kindergarten?"

"Because it is next door to the beautiful community center built by the government for the 20,000 senior citizens in their neighborhood and I thought you could do workshops in both places."

"How do you know about this?"

"I looked it up in the phone book and checked it out on my bike."

All the while we were having tea with the director of this center, I thought they were old friends. She and her assistant showed me the artists' studios, music rooms, large meeting hall with lovely gift shop, hanging scrolls all about, mixed with Chinese art. And they brought out special chairs to sit with us quite a long time, just visiting.

I assumed surely they were all old friends. "Oh no," Peter told me much later. " I biked over there last week and introduced myself and told them all about you."

So I am ready to move to Shanghai this afternoon. I could never be lonely. I know where to teach, where to exhibit. How to get to the Starbucks where Chinese artists gather on Sundays. Why the old men in McDonald's go there-for their protein early in the morning. How to find my way to the 38th floor of the swanky Marriott for a seafood birthday buffet, the memory of which will never disappear. And Peter and I will eventually sit on a park bench and talk about our ancestors, just as we already do.

His parents, wife and 19-year-old son live together in his parents' two bedroom apartment in central Shanghai. At 5 a.m. the elder couple leave to exercise in the park and go to the market for the day's food. Peter's wife leaves at 8 for her job in the bakery. His son works at Oriental TV ìwhere he is able to learn about and talk with all kinds of people.

Peter's official job is sales and public relations for the government Friendship Store. If all goes well with my work, our dreams and his Shanghai energy, together we will earn enough to put a down payment on a house for them in the suburbs, before we both retire.

Shanghai
November - December
2005

Alone. Journalartists have it better than most regular artists as the research, the listening, the travel, the conversations, before the work begins, give one the illusion you are not really alone as an "artist".

You are an interpreter, connector, glue gun, fishing net in the world of ideas, the ghost hunter chasing delusions.

But when the decision to "speak" occurs - canvas stretched, board primed, pastels and pencils lined up, rags clean, apron pulled on, one usually feels quite alone.

After November 20, 2005, this is often no longer the case for me. Nineteen years after I first set myself the challenge of transmitting without words to people of other cultures, I vision myself as the working part of a large vibrant oriental team.

How did this happen? When and where? And who are they?

It must have begun the day after I decided to decline an exhibition at the beautiful Liu Hai SuMuseum in Shanghai. Depressed with myself for holding to my invisible and probably unrealistic goal, of introducing my first paintings about Chinese life to Chinese of all income levels, I woke up chastising myself all over again. Was it really too far out in the suburbs for my bicycling friends? Were there truly no restaurants or dumpling shops to walk to, if people did not like my work? Should museums not charge artists? Would not this prestigious committee be insulted, misunderstand my long range goal and speak against me in powerful art circles? Mr. Fan, now retired head of the folklore collections at the stunning new Shanghai Museum of Art, who had recommended me and come all the way out there with me, would he not be embarrassed now to ever admit he had proposed me?

Peter Ge Jun Hua read my self-chastisement mixed with goal-oriented idiocy.

"We are going to Starbucks in another suburb this afternoon to meet an artist who works in a very good downtown gallery."

"Why? Usually only rich people, personal friends and family of the artist go to galleries. Or is it different in Shanghai? Would ordinary people take a bus or taxi all the way downtown just to see me?"

"No, but he has some ideas and he likes what you did."

"What did I do?"

"You spoke up for the poor people. And he says you are right."

"How does he know? I've never met him."

"I showed him your catalogs."

And that's how I agreed to sign up for the 2005 Shanghai International Art Fair sponsored by the Shanghai International Cultural Foundation November 16-20, 11 months later. I was told "many museums, foundations, common people, the rich, media, gallery owners will see what you are trying to do. You will gain a much greater perspective about us as well as a greater perspective about your work and what you are trying to do."

Thanks to local Chinese artist friends, I sent my application and my $1000 for a booth of 9 square meters (mistakenly thinking this was 3 walls, each 27 feet wide!) and promptly was scared to even go into my studio.

With 5,000 years of Chinese history fogging my entire thinking process, I froze. I knew immediately I could never do a collection for China like I had done for Greece and South Africa, in such a short time. Maybe ever. Peter's e-mails calmed me. He assured me he knew a QingDao gallery that had seen my work and would sponsor my first Chinese collection whenever I was ready.

This new commitment could be a sort of trial entry into their ancient culture.

So I literally went to bed. Put on the mindset of these Chinese friends.

What were they all interested in? What could I bring them, in ten months, that would have meaning from their point of view, on November 16? I.e.: tomorrow morning in exhibition planning terms.

Beijing 2008. Their first Olympics.

Ecstatic to have this honor, special buildings begun, budget under control, potential for business, fun, cross-cultural explosions in the very air, the Chinese excitement was deliciously visible.

But beyond all this wild expectation I realized I could make something for them that might retain special meaning, long after 2008: drawings of the ancient stone ruins of Olympia that accentuated the handwork of the stone masons, the great, great, great grandfather ancestors of the Greek people, whose stone labor insured that the concept of the Olympic Games would live on and travel for thousands of years all over the globe. And now, at last, to China.

Five paintings were already finished and stored on Hydra - stockpiled for my City of Athens municipal show September 19-30, 2006. Would they understand or care about this ancestor idea? This cradle of western civilization to cradle of eastern civilization? A to B: Athens to Beijing? Should I return to Greece quickly now? Climb back up there on those Pelloponesian rocks and do more? If they didn't like them or understand the gift, how would I get the framed paintings back to Piraeus by boat, from Shanghai, in time for the 2006 Athens show? How much could or would I lose?

Risk. All is a risk.

Everything ventured, guessed, speculated, paid in advance, anguished over.

Next Scene: Two weeks in rain, mud, lightning, crawling the rocks of Olympia again in my apron. Four months painting, matting, getting them photographed and on discs. Two more months doing six of the China Collection-To-Be: a temple door; Gui Lin dancer; a spoof ancestor portrait; a spoof "Fly Me to the Moon," after reading the Chinese astronauts were determined to beat us to Mars.

Accepted. Shanghai International Art Fair 2005. "And be sure to bring your sculpture," pleaded my U.S. Chinese friends.

"Oh no! I could never carry bronzes and paintings!"

"You have to. Our people will love your ideas in bronze even more. You have to take everything..."

Accepted: Shanghai Urban Sculpture Coalition.

But then, overheard in Shanghai, two days before the grand opening (brochures printed, framer found and paid, booth designed, bookmarks in two languages completed at Gui Lin Rd. printer) "..let's wait and see if they like it."

These were my two closest Chinese friends talking. Peter has been supervising the painting of my designs on 36" Shanghai heavy silk scarves for the past five years. And they were secretly unsure if the Chinese public would like or understand my work just before I opened the Shanghai Olympic Collection: "Grandfathers' Hands BCE Olympia."

I tell about this here to underline what it is like to work internationally toward an invisible long range goal, without the local umbrella of a gallery, agent or sponsor.

To remain intellectually free, it is sometimes very necessary to risk your own resources as well as to transcend the wisdom of even those on whom you depend (as well as consider your closest friends) in order to delineate a new pathway for what I consider to be a very much needed new international discipline.

Each culture has its entrenched subconscious measurement of "art" as they know it. Stripes and drips can be cherished in their time. For art has been evolutionary, often derivative, weaving its way through each culture according to the emulated. Art often simply feeds off its local roots, especially the roots that generate money or cachet watered by critics.

Art with a purpose has usually meant advertising: art that sells things.

Journalart has as its sole purpose bringing a conversation to the table. It is a search for the other half of the conversation opened by a stranger. There is no "style". Style implies intent.

Conversations are unique because the initiator and the listener are two unique separate beings. They need to "invent" in order to communicate.

When you are inventing, you are too entrenched to entertain a concept called style. Your local idea of "style", in artistic terms, could actually be a cloud formation, or a road block in international terms.

So because of this overheard conversation the day before I opened the Olympic stone collection at 10 a.m. November 16, 2005 in Shanghai, I felt the most unsure of myself in 17 years of international work.

Not unsure of my work, I am always emotionally attached to each concept. I can't just paint "something". I continually paint what I can't not paint. And these ancient cuts in the Olympic stones-the fluting, the crenellation of the empty pedestals, the math of the deep rectangular holes in the fallen matching column sections, still set the hair on my arms tingling.

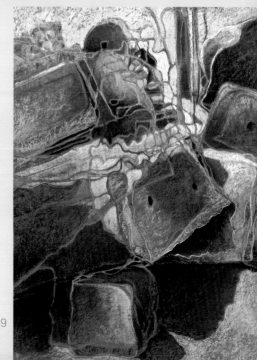

So it is with great joy and relief I report twice the security police had to be called to control the crowds!

Mr. Fan spent an entire morning at the booth...five days with no lunch... hundreds and hundreds of young people, grandparents, art professionals buying the Olympic 2008 calendar pocket fold-out, with 12 of the stone designs. Students, teachers, international crowds of collectors crowded our tiny too-small booth, perusing carefully the black and white Olympia photographs and comparing them with my wildly colored interpretations of the real stones.

There were dozens of invitations to teach, speak, collaborate, exhibit. An offer of $585,000 for the entire collection was turned down, in order to make sure the exhibition would tour to even larger audiences.

Reporter Fan Fan Meijing of the Shanghai Daily News won a three page spread from her editor to talk about my work. (When I called to complain the heading "Olympian Artist..." was outrageous and they should have said "Olympic", Scope arts editor Christine Zho laughed and countered that their chosen adverbial English was absolutely correct.)

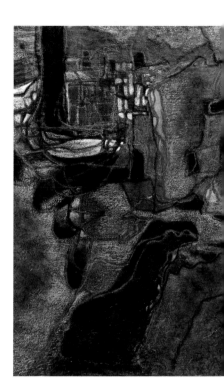

Oriental TV Media Group decided to feature my work in their new "no-budget" eclectic magazine FASCINATION. And to my great joy, at a meeting in his office, young editor Xiao Yun (who does not speak English) got a new gleam in his Chinese eye when Peter explained journalart to him.

"She's right! That's it! She's a journalist-one of us!" And now he looked at me even more seriously, realizing he was now going to publish his half of a "conversation" -in Chinese!

Xinmin Evening News international culture editor Hu Xiao Mang came especially, by appointment, to the apartment, after the show, invited by new Shanghai friends who wanted his point of view, in that he had not been in town for the actual exhibition.

A 20 year veteran reporter of their favorite Chinese newspaper, who spoke no English, he came through the door and I truly felt intimidated and totally inept without even a spatter of Chinese to welcome him. It was obvious they all knew and revered him.

For a very long time he prowled the contents of both bedrooms and living room, peering intently at each and every painting, raw or in cellophane for shipping. Now close, now at a distance, now returning to another he hadn't absorbed closely enough.

I really felt like running away. They told me during this interim that he covers musicians and artists all over the world-New York, Paris, etc. But my dominant thought was that he had probably wasted his time, finding this 11th floor apartment in a very conventional building in the suburbs. As grateful as I was that my friends wanted me to know him, I knew, in China, his opinion could matter even more than all the exhibition success. West meets East can be a collision.

Most people all over the planet want an "expert's" opinion when it comes to purchasing art. But when it comes to enjoying art...relating to it...remembering the image long after they have seen it, most people could care less what "experts" think.

But if experts and the general public respond at the same level, that, to me, is art that is worthwhile.

Because it seldom happens, I think that was the source of my fear. And the laws of probability, a Chinese well-recognized contemporary critic confronting a western civilization uneducated journalist, posing as an "artist", were quite obviously not in my favor.

But I gulped. Listened to the translation. Blushed. Bowed my head. And felt like crying. Although I didn't. Mr. Hu watched me almost too intently. And the others smiled. When Peter explained for me, in Chinese, that my goal was not to become rich or famous (and thanked him for both offers!) but that I needed help to found an academic division to exemplify what I am doing, he got up took both my hands and told everyone, in Chinese, that he would definitely help in every way possible.

He was so excited about the concept that they abandoned translating for me! And all jumped into "how" they could now make this happen!

And there were two other powerful Chinese leaders who aligned themselves with me before I left Shanghai December 7th.

Xi Rong Luo, owner of Realtime Publishing House, in the Xinghuang Industrial Zone outside the central city, offered to distribute, under his name and recommendation, 100 of these books to universities, writers, thinkers, government officials in China to help establish journalart as an academic discipline.

"But Mr. Xi, I don't know if I can afford the taxi fare to come way out here to work with you on the book."

"No problem. I'll send a driver for you", he said with a great wink that set Peter laughing,

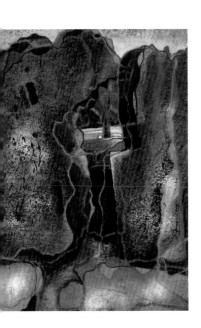

In that same industrial district, Vice President Zhu Denian of the Power Generation Group (who will cast my "Pendulum of Life" sculpture in bronze 65 feet long and 15 feet (approx.) high, in one of his many gigantic foundries) tells me a surprise story.

(Mr. Zhu is a very powerful and important man whose company, under his global leadership, provides one fourth of the power for the entire country of China. Most major corporations around the world, like GE and Seimens, cast their giant turbines and large industrial components under the guidance of Mr. Zhu and his talented company manager Mr. Zhang.)

When he had gone to Athens on business the morning after visiting my Shanghai International Art Fair booth, he decided to take his entire team of nine nuclear power experts to Olympia! By mini bus, they climbed the 6 hours into the Pelloponese mountains to see what I had been "talking" about, back in their hometown Shanghai.

So now I have a whole new team of Chinese cohorts. And I am talking with them, not painting. They want to know what I think. So I am assigning myself the first half of a lot of our future "conversations."

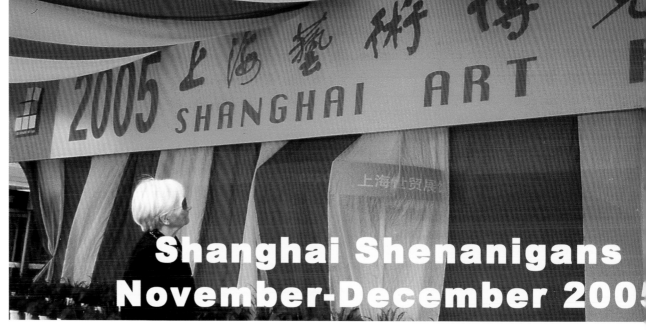

Shanghai Shenanigans
November-December 2005

Artist visitors to the pajama-clad residents of the hi-rise neighborhoods of Shanghai, with the user-friendly purple exercise equipment by the front door with its thousand-pebble circle path for tired bare feet, should stay alert.

There are subtle games going, uptown and downtown, designed to empty foreign pockets. Without a Chinese friend as your mentor (and even with one) you can find yourself starring in a dunce role.

On the second morning of the Shanghai show a western-dressed Chinese woman checked out my name above the booth and then said "Oh I hope no one has beaten me to this (gesturing to the sculpture). You're the talk of the exhibition! There are so many steps involved but first I have to make sure you get paid for your concept and then of course another fee for supervising the installation. Now in the meantime your color is gorgeous! The best I've ever seen. I need you so badly to advise me on a sculpture I have going up and could you go with me tomorrow to Beijing or as soon as possible?"

"Can I see it?"

"I'll come back tomorrow and show you. Oh I'm so thrilled to find you."

Gao Xian Chen,Ge Jun Hua,Jiang Guo Qiang

On the third morning: A leather-jacketed Chinese photographer with reversed baseball cap, official looking tags in Chinese around his neck, handed me a business card with Shanghai Cultural Development Foundation printed in English. He spoke only Chinese.

While he explained to Peter that he was preparing an exhibition of his own work for NYC, he used outrageous body language to show me how he wanted me to pose-one half hour of work (with the sculpture as background) hand up, hand down, left, right, glasses, no glasses, etc.

Mr.and Mrs. Fen

We both were sure he was sent by the foundation for publicity shots re the sculpture purchase.

Day Four - Tall man with camera spends too long making sure he has all of the gift cards of the Olympic stone reproductions. Peter chases him away, realizing he plans to go into business copying the entire collection for prints.

All gifts cards now go under the table. NFS.

Day Six - At our apartment an entourage of foundry expert, computer specialist, administrative assistant arrives, trailing agent who has "sold my sculpture" to government on day two.

She lays out the colored drawings of the sculpture needing "color change."

"Whose is it?"

"Oh, it doesn't matter. Just someone from Korea. I changed the shape."

I go into detail about need to see site

Mr.and Mrs.Zheng

in light, shadow etc. and indicate obvious advantage a special installation "viewing structure" would offer.

"No time."

My reluctance to get involved with someone else's work is visible. Tells Peter she will call tomorrow.

Day Ten - 7:00 a.m. Photographer at door! Comes right in without acting apologetic. Demonstrates with extreme gestures that he has come many times and I am never home.

Artist and her Guest

In great hurry. Hands me 12 disastrous pictures of myself plus bill for 800 yuan ($100).

I cannot speak Chinese. So cannot explain we all thought the Cultural Foundation had hired him for their publicity re: the "sold sculpture."

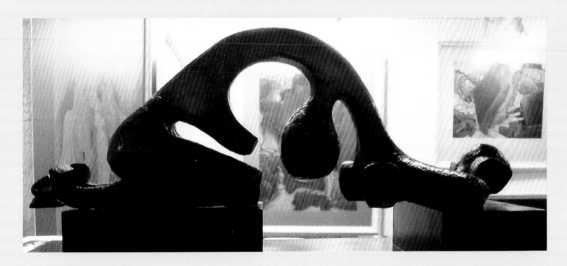

He pulls out his pocket translator: "Need to go to work. Need to be paid $100. Good pictures. Professional."

Trapped. Half what we would pay in USA. Give him 800 yuan.

Peter arrives at nine. Opening of One Week Smoldering Storm: "Never ever give someone money, so much money, without checking local price."

Photographer has tricked us all. Has no connection to foundation. Obviously knocking on door so very early to be sure Peter would not be around. Pictures worthless... "160 yuan ($20) more than enough and you did not hire him in the first place! You really owed him nothing. We should sue him for misrepresentation and alert the professional group he claims he belongs to..."

The sculpture agent? She never called Peter the following day-the same day the Shanghai Daily News feature decried the lack of "iconic sculpture" in the city.

Peter himself then brought "Pendulum of Life" to the Shanghai Urban Sculpture Coalition office and it was approved by their committee, who have now recommended it for final approval and site allocation to Beijing government officials. The agent who was so "thrilled no one had gotten to you first" had actually done nothing.

The sculpture, "from the artist in Korea," turned out to be a manipulated Jeff Koons, appearing in its original form and color in one of our stockpiled magazines when we arrived home.

Mrs.and Mr.Xuan, Vivian Chen

So cross-cultural journalart work has its downers. It's good if you are lucky enough to have a local person run interference for the scatter-shot collisions public exhibitions always yeast up.

But better if you know a bit of the language or can hire a translator to help you run the booth, so you can harness the perennial poseurs.

However, there are occasions you and your translating friend may not agree. Like the night Peter accused our cab driver of adding one yuan to the meter while we unpacked the trunk. The car was not moving, from Peter's point of view. And the customers weren't watching the money machine, like Peter always assigns himself to do.

From our point of view, we were still using the cabby's vehicle and the load in the trunk was large. But the Shanghai communal code is "one helps others under all circumstances and one does not take tips for that."

Therefore, adding money to the meter was, for Peter, like giving yourself a secret tip that these foreigners wouldn't know about.

I can still hear him berating the driver in a loud voice as the cab slinked away.

The Crossroads: East-West. We actually made a pact. There would be many more moments ahead like this through the years, when culture and custom explode head-on. We agreed that whenever either of us feel we are absolutely in the right, voices raised, secretly swearing, while the other is turning purple with fury, that we will shout "East-West!"

We'll stop everything to dissect the double concrete roadblock our great, great grandmothers and grandfathers have evolved in front of us. And carve a shared road.

Which brings me right back to where the concept for journalart began, 19 long years ago.

Artist & Mrs.Fen

Memories, Mirrors and Motivation

One thing we can never be sure of: how we affect others.

It is very easy to observe, describe, moralize, analyze those we know. But asked to describe the imprint we make on them...what our words, actions, overall behavior and mannerisms express to another's point of view is always a mystery. We can conjecture. But we can never see an accurate 24 carat reflection flashed back from the mirror.

What we see is not what they get. In cross cultural terms, never do they see what we get and vice versa.

Amplified in planetary international terms, one can easily recognize the seeds of war. (Add over 11,000 religions dedicated to helping each of us die and hundreds of thousands of dialects, and the potential for constant disagreement and misunderstanding is mathematically unlimited).

Thinking backwards, that is where this book began: as an antidote to our essential selves. A search for a way to match mirrors of behavior. To find patterns and partnerships, without the burden of words, that underline the need to heal us together as shared tenants of a common sun, a common moon.

It is my sincere hope I am not the same person who wrote chapter one here or the person who painted 45 paintings about Spanish and Welsh life nearly 20 years ago.

All I can be sure of is that my actions, my taking the risk of making a fool of myself by trying to transmit non-verbally to strangers, has generated crowds of young people, educators and professional journalists as new friends in many countries.

So remembering the dozens of gifted Chinese artists sleeping in their booths at the Shanghai International Art Fair, exhausted from working their day jobs and painting through the night, I am even more motivated. I want to help them acquire a long range vision of their great talents that demonstrates to Chinese government officials these are sleeping missionaries who deserve journalart assignments.

Those two dozen gifted and impoverished Zulus who achieved so highly in transmitting their ideas in my Durban workshop at the BAT center, should be organized into journalart management teams. They could easily guide others like themselves to "speak" for and about Africa, helping curb the violence, apathy and disenchantment around every back street, both in their hometown and the entire African continent.

Journalart talks. That's how journalartists "marry" intellectuals with the street smart.

Later, when one moves on to work cross-culturally (often not speaking the language) the joy and gratification of arousing the highly educated together with those who cannot read or write, is solid evidence of our mutual interior overlapping experience.

It can be presented visually. Observed, mapped, displayed with the skills of art, journalart becomes evidence.

Despite artificial nationalistic boundaries, it is evidence we are all citizens of an unseen communal collective that makes us laugh, smile, cry together.

When a journalartist leaves home and transmits, through his or her work, this kind of "evidence" (after many months, maybe years of research) everyone becomes immediately aware these paintings are not about the artist herself/himself.

With a great deal of hard work the journalartist has become able to "speak"-to enter the everyday reality of the viewer.

They now experience art constructed not for purchase, but for a purpose: sharing.

Motivation at the source has evolved a new language of transmission.

How to bring this transition about on a very large scale, internationally? That is my next challenge. It will require, at the university level, an entirely new academic division, combining the skills of art with those of international relations. It will require evolution of a new style of academic professionalism. It will require realignment of how we think about art and how we think about international studies. It will require new measuring techniques for evaluating a new concept.

Can we continue to separate our intellectual lives from a responsibility for individual international transmission? No.

Here I will only delineate Step One: In order to learn and grow and change (as I have had to learn and grow and change) one must jump into space and risk in either of these two modes:

1. Fantasize you are the very first person born on this huge planet. Your assignment: to make sure there is a system in place that will enable all the people who come after you to know and understand each other.

2. Simulate you are the last person left on this dying planet who is given one last chance to start over and change everything.

Whichever you choose, you will be on my road.

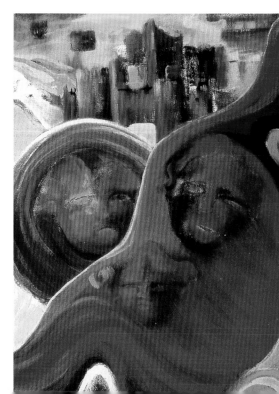

Countdown

Mark Levy & Associates, PLLC

Press Building
19 Chenango Street
Binghamton, New York 13901

Tel: 607·722·6800
Fax: 607·724·2207
[...] [...]

Mark Levy
Admitted in NY & FLA

Virginia Brown
Admitted in NY

Senior Technology Advisor
David L. Banner
 Registered Patent Agent

Patent Agents:
Maxine L. Barasch
 Registered Patent Agent
Bruce Resnick, Ph.D.
 Registered Patent Agent
Paul E. McNamee, Ph.D.
 Registered Patent Agent
Risto A. Rinne, Jr.
 Registered Patent Agent
Edward J. Vytlacil
 Registered Patent Agent

September 11, 2006

Ms. Jaquelyn Thunfors
P.O. Box 814
Southport, CT 06490

Re: JOURNALART Service mark

Dear Jaquelyn:

Enclosed, please find a copy of an Examiner's Amendment dated September 6, 2006.

Congratulations! As you can see, the Examining Attorney found no similar registered or pending mark which would bar registration of JOURNALART. Therefore, your mark will be published for opposition soon.

We accepted the Examiner's suggestion for the recitation of the services. The recitation of the services now reads:

IC 41; educational services, namely, providing seminars, workshops and classes featuring intellectual exercises that incorporate artistic skills or artistic transmission via drawings, paintings, sculpture or other non-verbal communication media.

Once again, congratulations! We will keep you informed of further developments.

Best regards,

Mark Levy

ML:mlb
Enc.

Tonight in my Asiana Airlines midnight aisle seat 62, flight 221, JFK to Shanghai via Seoul, I lead myself into a numbers game. My right foot, crucially, has to stay alert. My head has to follow and keep itself entertained.

In the cabin darkness, my mid-row Korean fellow passenger, taking advantage of the empty seat between us, has slipped to the floor onto his stretched-out airline blanket.

I return from the W.C. to find his spiked-hair head and snoring face where my right foot has paid $450 for its half of the 18 inches beneath my seat.

It takes me about half an hour to decide the politically correct thing to do. I glide from "Oh well" to "Keep yourself calm", to "Make believe you are in prison, a Stalinist dissident. Your job is to entertain yourself, maybe for 13 more hours, not 13 years."

Question for prisoner: How does this November 24 fit into the picture of your life's work? Immediately it's 1948 and I am in Dey's department store, Syracuse, N.Y., buying a black persian lamb pillbox hat. No one would agree to open the conference and be responsible for the opening remarks from the speaker's table.

As head of Theta Sigma Phi, Syracuse University journalism honorary, I had convinced town and gown leaders to let our group organize a first annual public relations conference for the non-profit organizations of the city of Syracuse, sponsored jointly by the university and local newspapers and radio stations.

Having been required to do projects for both the Syracuse Post Standard and WFBL, in order to get my BA Journalism, I was shocked to see the caliber of material dropped off by these groups-scribbled notes, postcards, personal stationary, letters, faded photographs, colored pictures with no contrast, impossible to use in an era of black and white newsprint.

It has to be two full days I convince them. "We'll rent space at Hotel Syracuse, have a lot of editors, photographers, and announcers conduct workshops. Professors can discuss their specialties etc. Our team will do a mailing list, send notices and invitations, and see what happens. People can sign up for what they want or need help with-radio spots, letters to editors, articles, community notices, fund raising campaigns, etc."

Of the nearly 600 invitations sent, 95% said "We're coming!" An opening luncheon became a necessity. No speaker. I owned one serious wool suit: royal blue and black houndstooth check with round persian lamb collar. In 1948 one did not address a large crowd without a hat. Tired of begging professors and editors to do this hated crucial job, I decided I would save a lot of time by just buying a hat and commiting myself to worrying about the long list of more important headaches this project required me to solve.

(I was very big on saving time in those days. Not only was I a dual major in journalism and English literature, I had my job with the Community Chest of Syracuse doing publicity, was Chief Justice of the Women's Student Government court, did feature stories for WFBL now and then, and continually tried to concoct magazine articles.

Time was so much "of the essence." Long hair was a prime nuisance. I quickly brushed my Macy's dry shampoo through it to remove the oil, re-wound it around my ears, braided, Swedish-style. With the pillbox on top, I hoped to look sufficiently professional and stylish enough to glide through the crucial opening remarks.)

Just in case we needed something to hand out, I put together "How to Get the Publicity You Deserve."

For over 20 years this conference continued. In its heyday Gloria Steinem came to Syracuse and presented Syracuse University awards in her mink. In some years it diminished to a one-day event. Then it became two again. A women's page editor, in a feature article about it, recapped her memory of me years ago. When a young journalism major came to her office to recommend making the conference a two day affair instead of one, "My dear girl, you are re-inventing Jackie's wheel."

So it occurs to me, in this blackened jumbo jet cabin over the Bering Sea, that if I am awarded this jounalart trademark, officially, in ten more days, that I have been working to bring people together to share ideas and to help each other, for most of my working life. The only difference is, with journalart, I have shifted to cross- cultural challenges, trying to transcend language hurdles with non-verbal transmission: art.

With the flashlight close to his face, the Korean stewardess orders him to get up and return to his assigned seat. He springs up and folds into it, the blanket now covering his face. Sleeping, so it could have been an hour, three hours, or 40 minutes later, I feel "fingers" inching along over my toes! Terrified, half awake, I reach down and find his Korean bare toes trying to find a way around my right foot.

Almost simultaneously I realize I am only able to see so well because three stewardesses, with three flashlights, are now demanding he immediately get his head out of the opposite aisle!

Journalart's legal adventures will now be memorable in Korean dimensions as well.

Grandfathers' Hands
Shanghai to Athens
September 2006

By the time American ambassador to Greece , Charles Ries, arrives at my opening reception for Grandfathers' Hands BCE Olympia, sponsored by the City of Athens Cultural Foundation at the Cultural Center, 50 Academias St, Septenber 19, 2006, I am already obsessed by the plump elderly lady in long pink silk dress. Her sturdy shoes and serious stockings tell me she must be an abandoned grandmother, or mother of a peripatetic guest.

Pouring over the edges of a sturdy metal chair toward the rear of the hall, she looks both regal and anxious. Each time I approach and attempt to talk with her, she waves me away. Once she disappears, then I see her back in her seat. I continually watch for her daughter or son to retrieve her. I am so worried about her abandonment, in this crowd of nearly 300, that even the embassy security guards, in their navy double-breasted suits concealing the guns, look normal.

Ambassador Charles Ries, Kristen T.Ball

Editors, economists, writers, publishers, fellow artists unwittingly identify themselves early in the evening by the paintings they continually return to- We Are All Sailors Without Work and Dreamers on the Star Trail of Homer-Sir Arthur Evans and Heinrich Schliemann.

By this third exposure to the Greek public, I know these two pieces talk strongly without me-the former about how we are all tied together globally, whether we like it or not, and the latter about the incredible and enduring difference two strangers, from two faraway countries, can make, in defining your local history of yourself.

Although this exhibition is by far the most difficult we have had to hang- Olympic stone drawings flown from Shanghai; Hydra collection lashed onto donkeys 1000 steps above the sea, then three and a half hours by ferry to Piraeus, then onto a huge truck 40 minutes into Athens- it is a gigantic example of teamwork meshed into this shared moment of celebration of the common man. Just as in Shanghai last November.

Round and round the exhibition hall I overhear discussions about the Greek ordinary stone masons who cut these two-foot deep slots into stone that enabled wood timbers to hold the Olympian columns up in sections-true hands-on evidence we can all see and touch, thousands of years later.

As we are packing it up Sunday afternoon, economist Angelos Antonaropoulos stops by for the fourth time and tosses me a tabloid newspaper. "Now read this! I knew you didn't believe just me. We are even having dreams about this show. Here's your proof ! I just picked it up at the bus stop-free press for everybody!"

Jacquelyn Thunfors

«Χειρών έργα Αρχαίων Γλυπτών»

Η J.T. διέκρινε πάνω στους θρυμματισμένους κίονες, που κάποτε στήριζαν τον λαμπρό ναό του Δία στην Ολυμπία, τ' αποτυπώματα των χεριών αρχαίων σμιλευτών. Μέσα από σχήματα και χρώματα έγραψε μία δική της ωδή και μας καλεί σ' ένα προσκύνημα στον μόχθο εκείνων, που ακόμα στηρίζουν την ύπαρξή μας χιλιάδες χρόνια μετά.

Μέρος των έργων αυτών εκτίθενται στην Κίνα προαναγγέλλοντας τους Ολυμπιακούς αγώνες στο Πεκίνο το 2008.

Η έκθεση πραγματοποιήθηκε με την ευγενική αρωγή του πολιτιστικού Οργανισμού του Δήμου Αθηναίων και την συναδελφική βοήθεια της ζωγράφου Άντζελας Θεοδωροπούλου.

By this third exposure to the Greek public, I know these two pieces talk strongly without me-the former about how we are all tied together globally, whether we like it or not, and the latter about the incredible and enduring difference two strangers, from two faraway countries, can make, in defining your local history of yourself.

Although this exhibition is by far the most difficult we have had to hang- Olympic stone drawings flown from Shanghai; Hydra collection lashed onto donkeys 1000 steps above the sea, then three and a half hours by ferry to Piraeus, then onto a huge truck 40 minutes into Athens- it is a gigantic example of teamwork meshed into this shared moment of celebration of the common man. Just as in Shanghai last November.

Round and round the exhibition hall I overhear discussions about the Greek ordinary stone masons who cut these two-foot deep slots into stone that enabled wood timbers to hold the Olympian columns up in sections-true hands-on evidence we can all see and touch, thousands of years later.

As we are packing it up Sunday afternoon, economist Angelos Antonaropoulos stops by for the fourth time and tosses me a tabloid newspaper. "Now read this! I knew you didn't believe just me. We are even having dreams about this show. Here's your proof ! I just picked it up at the bus stop-free press for everybody!"

Jacquelyn Thunfors

«Χειρών έργα Αρχαίων Γλυπτών»

Η J.T. διέκρινε πάνω στους θρυμματισμένους κίονες, που κάποτε στήριζαν τον λαμπρό ναό του Δία στην Ολυμπία, τ' αποτυπώματα των χεριών αρχαίων σμιλευτών. Μέσα από σχήματα και χρώματα έγραψε μία δική της ωδή και μας καλεί σ' ένα προσκύνημα στον μόχθο εκείνων, που ακόμα στηρίζουν την ύπαρξή μας χιλιάδες χρόνια μετά.

Μέρος των έργων αυτών εκτίθενται στην Κίνα προαναγγέλλοντας τους Ολυμπιακούς αγώνες στο Πεκίνο το 2008.

Η έκθεση πραγματοποιήθηκε με την ευγενική αρωγή του πολιτιστικού Οργανισμού του Δήμου Αθηναίων και την συναδελφική βοήθεια της ζωγράφου Άντζελας Θεοδωροπούλου.

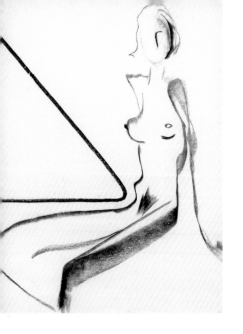

Not only have they printed a color picture of Olympic painting number 11, but the reviewer truly confirms, in print, that journalart is working..."Painting with dancing contours and special shapes, all her creations bring us back thousands of years to ancient Olympia"..."her own approach to celebrate the hard work of all those people who created our history"..."thus she succeeds in uniting the people themselves."

Gratifying. Truly humbling. Total repayment for the energies of all of us, to bring this collection "home."

And the grandmother in pink silk dress?

Traditionally, in Greek exhibitions, food is served outside the show space. Our central hall buffet for 300-puff pastry with roquefort cream, Swedish meatballs, tiny spinach and cheese pies, vegetable crudites, miniature sandwiches, pastries, grapes, melon. red and white wines-was a true Mediterranean feast.

Two evenings later the University of Finland sponsored an installation across the hall. Boxes of miniature pizza and cheese puffs, with large bottles of soft drinks, appeared on their buffet table, for mostly student guests.

Who was sitting on the hall sofa eating, in her same long pink silk dress, now with evening bag to match? Our "grandmother": Athens Cultural Center professional opening night gourmet.

Mark Levy & Associates, PLLC

Press Building
19 Chenango Street
Binghamton, New York 1390

Tel: 607•722•6600
Fax: 607•724•2207
patents@marklevylaw.com

Mark Levy
Admitted in NY & FLA

Virginia Brown
Admitted in NY

Senior Technology Advisor
David L. Banner
Registered Patent Agent

October 10, 2006

Ms. Jacquelyn Thunfors
PO Box 814
Southport, CT 06490

Patent Agents:
Maxine L. Barasch
Registered Patent Agent
Bruce Resnick, Ph.D.
Registered Patent Agent
Paul E. McNamee, Ph.D.
Registered Patent Agent
Risto A. Rinne, Jr.
Registered Patent Agent
Edward J. Vytlacil
Registered Patent Agent

Re: JOURNALART trademark

Dear Jacquelyn:

Congratulations! Please find enclosed a copy of the Notice of Publication we received. Examination of your trademark application is complete. Your mark will be published beginning October 24, 2006 for thirty days in the USPTO Official Gazette. The purpose of publication is to allow any person who believes s/he will be damaged by the registration of the mark to contest the mark prior to registration. If no opposition is filed within the 30 days, the U.S. Patent and Trademark Office will issue a Certificate of Registration.

Once again, congratulations! We will keep you informed of further developments.

Best regards,

Mark Levy

ML:cf
Enclosure

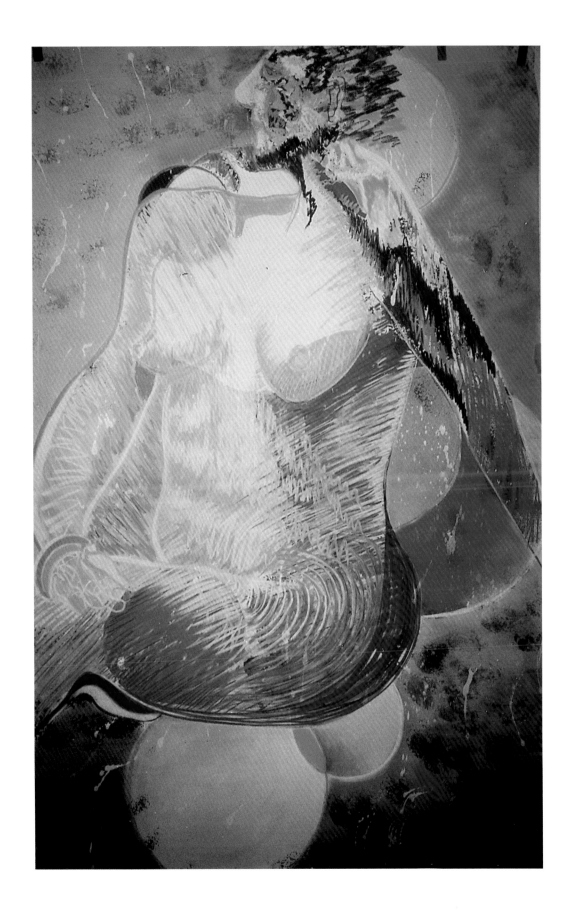

jolly ['dʒɔli] *a.* 快活的,兴高采烈的 *ad.* 很,非常 *v.* 开玩笑

jolt [dʒəult] *v. & n.* 颠簸;震摇;猛击

joss [dʒɔs] *n.* (中国的)佛像,神像,偶像 ～**stick** *n.* 香

jostle ['dʒɔsl] *v. & n.* 拥挤;推撞;竞争

jot [dʒɔt] *n.* 一点儿;少许 *vt.* 草草记下

journal ['dʒə:nl] *n.* 日记;议事录;报纸;杂志;日记账 ～**ism** ['dʒə:nəlizəm] *n.* 新闻业;新闻工作;报刊;新闻学 ～**ist** ['dʒə:nəlist] *n.* 新闻工作者

<<< **Journalart** 无声胜有声

journey ['dʒə:ni] *n. & v.* 旅行;历程 ～**man** *n.* 雇工

joy [dʒɔi] *n. & v.* (使)欢乐;高兴 ～**ful** *a.* 十分喜悦的 ～**less** *a.* 快快不乐的 ～**ous** ['dʒɔiəs] *a.* 喜气洋洋的

jubilant ['dʒu:bilənt] *a.* 欢呼的;兴高采烈的

jubilation [dʒu:bi'leiʃən] *n.* 欢欣;欢腾;庆祝

jubilee ['dʒu:bili:] *n.* 佳节;庆祝

Judaism ['dʒu:deiizəm] *n.* 犹太教

judge [dʒʌdʒ] *n.* 审判员,法官;评判员 *v.* 审判;评定;下判断 **judg(e)ment** *n.* ～ **debt** *n.* 判定债务 ～ **seat** *n.* 法庭;审判席位

judicature ['dʒu:dikətʃə] *n.* 司法;裁判权;法庭

judicial [dʒu(:)'diʃəl] *a.* 司法的;法院的

judiciary [dʒu(:)'diʃiəri] *a.* 司法的 *n.* [总称]审判员

judicious [dʒu(:)'diʃəs] *a.* 贤明的;明智的,审慎的

jug [dʒʌg] *n.* 壶;罐 *vt.* 炖,煨

juggle ['dʒʌgl] *v. & n.* 变戏法;欺骗

jukebox ['dʒu:kbɔks] *n.* 自动电唱机

juice [dʒu:s] *n.* 汁液 *vt.* 榨汁 **juicy** ['dʒu:si] *a.* 多液汁的

July [dʒu(:)'lai] *n.* 七月(略作 Jul.)

jumble ['dʒʌmbl] *v. & n.* 混乱;混合 ～ **sale** *n.* [英]旧杂货拍卖(或义卖)

jumbo ['dʒʌmbəu] *a.* 特大的 *n.* 庞然大物

jump [dʒʌmp] *v. & n.* 跳跃;暴涨;突变 ～**er** *n.* 跳跃者;短上衣;圆领毛线上衣 ～**y** *a.* 跳动的;易于激动的;受惊的

junction ['dʒʌŋkʃən] *n.* 连接;接合点

juncture ['dʒʌŋktʃə] *n.* 接合点;关键时刻

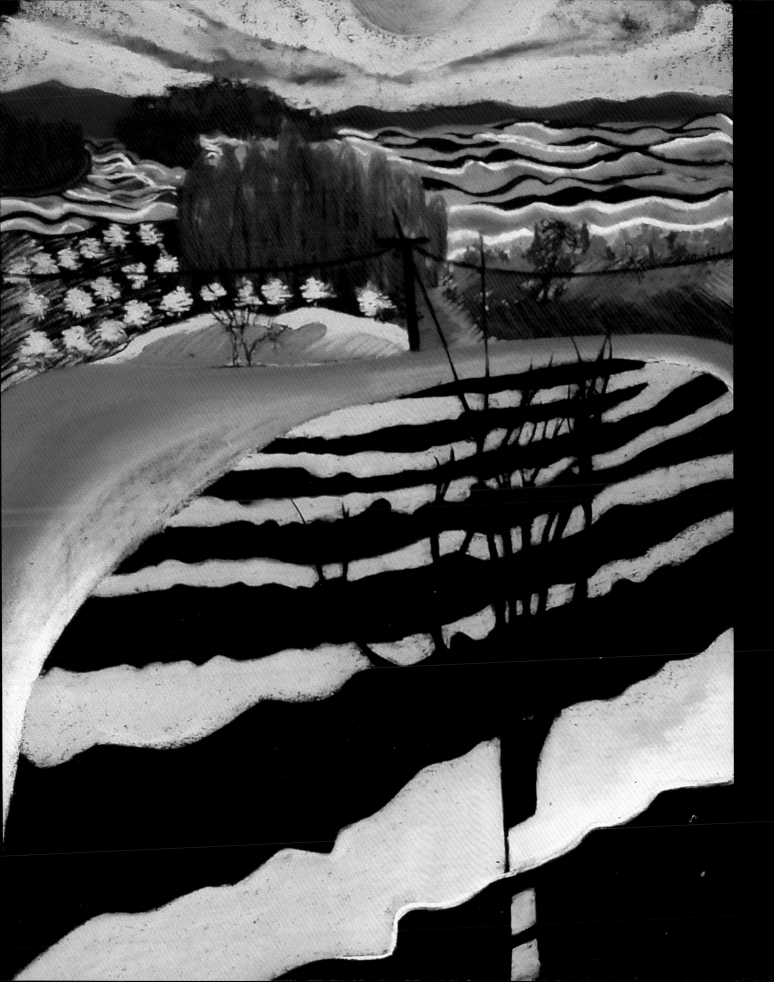

卡尼娜码头餐 Kamini Taverna
Dock

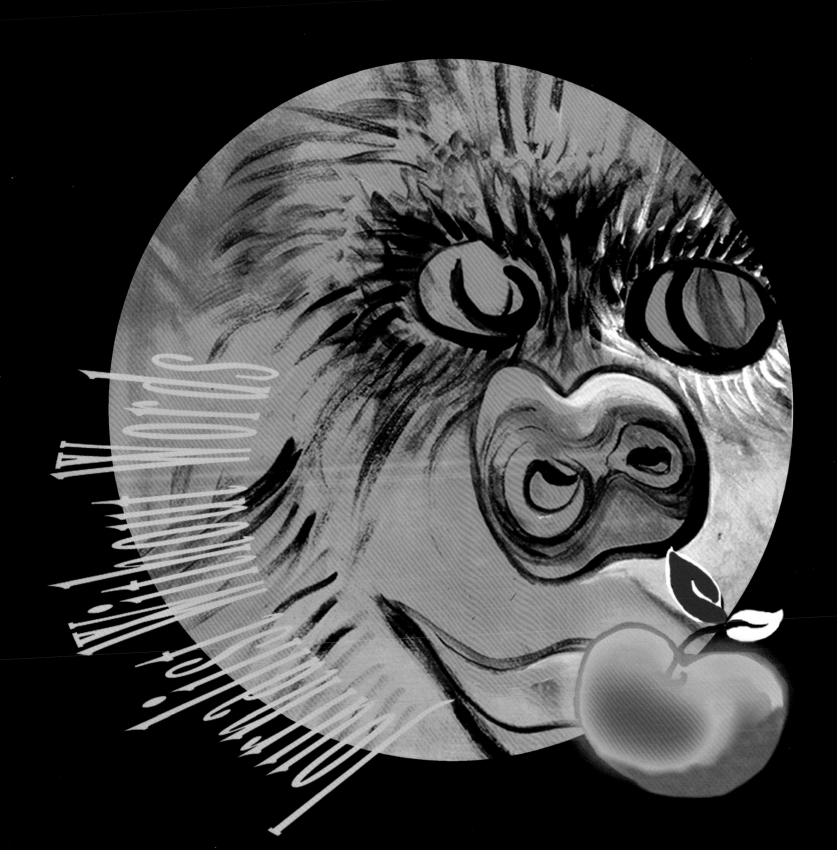

走向文明

But How
Did We
All Lose
Our Fur?

命
运 Thou Art Slave To
Fate, Chance,
Kings and Desper-
ate Men
—John Donne

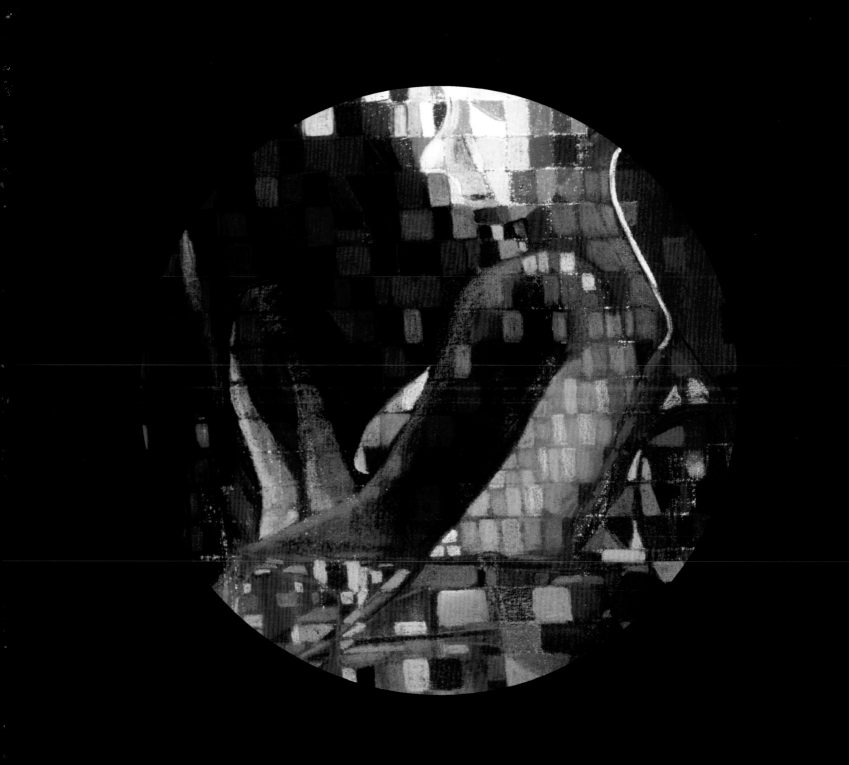

母亲 Mathematics
亲 of Eve

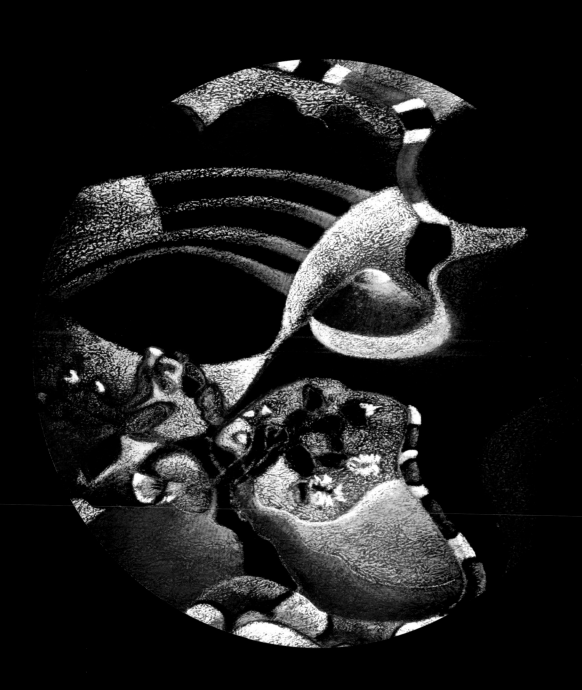

你爱着我　Your Love For Me

我们在寻找 We are
all sailors
without work

Acknowledgments

If I were as talented as I would like to be I would compose for you here a huge Brueghel-style action painting of the following gigantic international bouqet of people who enabled this 19 year odyssey to happen.

It would yeast with color and energy, lift you up into soaring goodwill, transport you on to moments of unbelievable generosity tomorrow morning. Or even this afternoon.

Unfortunately no painting could ever match the multiplex experiences, advice, guidance and gifts of time and encouragement provided by this generous multinational, multigenerational galaxy of human beings.

Each helped me in a special way either to literally or spiritually transport me, or to educate and inspire me across 19 flying years of journalart work.

In Greece

Both the Hydra collection and the Olympic stone collection were inspired by my daughter and son-in-law Kristen and Axel Ball, who lured me to Greek island life, without cars , many years ago. Petrous and Maria Kladakis gave me a tiny studio in their Orloff Hotel garden and before long I was trying midnight street scenes, burying myself in Cafavy and Seferis and going to bed with Pausanius. Most of this book was written in several hot afternoons at a waterfront bar on Hydra.

Greek friends, neighbors, printers, translators, framers, writers, museum staff, advisors who helped bring these two collections to life: George Christopholous, Babis Shinas, Maria Comninos, Nicholas and Alexia Davles, Christos Palamides, Tassos and Mary Yannopolis ,Barbara Nielson, Zoe Georgiou, Ms. Belle and G. Wesson, Birgitta Nordhus, Charles and Mary Young, Joan Psarapoulou, Marina Spanou, Nickie Achimastos , Stelio Bougiouklis, Yurgo, Eleni and Dimitrious Perras.

The Dimitrious Labropoulos family , Irene Pavou, Helga Romeli, Angelo Antonaropoulos, Tassos Kavalieratos, Christos Antonaropoulos, Mary Papadopoulou, Angelina Canellopoulos, Dimetrious and

Angela Theodoropoulos, Kari Ostgaard, Katerina Panagiotopoulos, Vivian Kampouri, Vangelli Rafaelis.

Marie and Iro Kontopithari, Phililp Stavridi, Mitsis Drakopoulos, Klimis Karamanoglou, mayor Constantinos Anastopoulos, Christos Borias, Nicholas Dupis, Costas Forlas, Linda Leoussi, Stelios Trionis, Maria Gouma, Christy Papadopoulou, Lefteris Klafas, Christina Andreou, Vagilis Rousis, Tato Sossai, Captain Blahopoulos, Kathy Owyang ,Ikona Printing staff, Jean Mark Nehme, Vana Kontomerkos, Janet, Ada ,Ethel, Alexis, Tina, Stella, Mary and Constantinos of the Art Gallery hotel, Vicki Blatsou, Lili Marcopoulos, Mania Trimi, George and Harikleia Dionision, Elena Liatra, Mrs Franasoula, Costa's water taxi family, Vasilaki Cornices and the staff of the Delfini pensione, Hydra.

In China

Tony Li Zhicong and my deceased partner Roland Smith , together with Chung Yeh, are responsible initially for luring me to China. I owe them immeasurably for the enduring depth of inspiration I constantly discover here.

My Shanghai partner, Peter Ge Jun Hua, has enabled me to hurdle language barriers and feel totally at home with the following friends, neighbors, fellow artists, professors, writers and educators. Without him this book would still be floating in my head.

Yaohui Wu and family, Chao Hui Cai ,Yan Zhong Hou , Zhu Denian, Zhao Yang , Nancy Zhou,Vivienne Chen, Daniel Liang, Yan Zhong Hou, Hou Jinling, Mr. Tong , William Jin , Gao Xian Cheng, Xi Rong and Judy Luo, Gu Jing , Zheng Jia Shi, Michael Sun, Hu Xiao Mang, Leslie Ge , Eason Zhang, Christine Zhu, Mr. and Mrs. Fong and Fong Lu, Fabio Cucinella, Yu Fang Jiang, Mr. and Mrs. Feng, Tien Bin Nan.

Xiao Ming Yang, Lynn Zhicong, Fan Fan Meijing, Sophie Shaw, Guan Yuliang , Fan Ming San, Yang Fang Ling, Chen Xi Yan, Zhou Jian Ming, Zhou Xing Guo, Mr. and Mrs. Sun Yong Hai, Yuonne Zhang , Mr and Mrs. Xuan de Gong, Connie Wang, Stephen Min, Mu Ya Feng, Sophie Nilsson, Bai Ding, Mr. and Mrs. Zeng Long, Rachel Shen, Mary Yang, Zhang Hua Tao.

I remain deeply indebted to the staff of the Shanghai Daily News, Shanghai Citizen News, and the Oriental TV media Group.

In South Africa

My hosts for many research trips exploring the country-the van Rensburg family (Ado and Fiona, Natasha, Cherie and Angelique) and curator of the collection ongoing- Reginald Letsatsi, are my soulmates in helping to interpret contemporary South Africa. Without the thoughtful guidance of Christopher Randelhoff and staff of the cultural department, Kwa Zulu Natal, together with Nontobeko Ntombela, head of the art department , Durban University Technicon, the South African collection would not be getting ready for its third opening April 2007.

Invaluable friends, helpers, guides, advisors, students: Marianthe Van der Walt ,Thule Mkhize ,Felizia and Joyce Majola, Dirk Oegema, Dr. Limor Gedansky, Lisa Van Wyk, Zandile Mkhize ,Shaun Dunn, Neliswa Mrobo, Manie Jooste, Clement Mazabuko ,Simo Shezi ,Simo and Gabriel Khumalo, Mthandeni Dladla, Umani

Zuma, Sanele Mugandu, Themba Phumhani Gasele, Hlengiwe Bothelezie, Winnie Ngrobo, Sbusiso Kati,

Simabonga Mofokeng, Xolan Khumalo, Mokgoko Neo ,Khumalo Thembinkosi, Mohele Petros ,Moindla

Khumalo, Mbhekiseni Hlongwa, Sandile Buthelezi, Sbusiso Gwala, Bonjani Sithdie, Leslie Arthur, Anita

Viljoen, Gert and Gerda Swanepoel, Linda Fortune ,Bonjonl Mdhlow, Tessa Erafe, Yolanda Crouch .

Kevin Strydom ,Jermaine Peters ,Charlene Stuart, Jennifer King ,Du Du du Preez, Katie Anderson,

Dora Von Meyer, Derrick Thomas, Rafick Moosa, Anthony Wade, Jenny Mcdonald, Yolani Mchunu, Noel

Loots, Martha and Piet Labuschagne, Jonnie Von Rensburg, Jonti Olivier ,Esther and Fortunate Chadi ,

Kobus Randelhoff, Peter Harris, Hennie Kruger, Frank Ledimo.

R.J. Van Kraaenburg, Gerhard and Miemie Snyman, the Hoagland family, Ansa Liebenberg, Denis

Walwyn, Mr. and Mrs. Boland, Piet and Christine Van Rensburg, Linden Hardy, Jonas Stahlbage, Irene Marais

,Dr Paul Bayliss, Dr. Johan Broodryk, Dr. Loubser, Pam and Norman Walton, Owen Jinka, Penny and

Jeremiah Letsatsi, Iolanthe Randelhoff, Monica Du Plessis ,Bruce and Deborah Mary ,Merzia and Wilhelm

Steenkamp, Himla Soodyal, Joan Burton, Judge Leo Van Den Heever, Dr. Francis Thackeray .

My special thanks also to the staff of Pretoria Academic Library, staff of Durban University Technicon

gallery, the City Lodge, Pretoria 24-hour team, and the South African Independent editorial staff.

In the United States
Spain, England and Sweden

My partner and friend Edward Gollin, four daughters Lowell, Merrill, Kristen and Jacquelyn, Brian Hurley, Axel Ball, Nicholas Gyllenkrok, and my 11 grandchildren are all a consistent nourishing force in my life What I learn each day, from them, enables me to learn from many others.

My artist friends have set for me a high, nearly impossible standard: Pat Yallup, Georgette Bolling , Jo Taylor, Phillipa Pokras, Beth Noble, Stanley Bleifeld, Jackie Kauffman, Julie Parker, Mary Edwards, Ricardo Gago, Sally Aldrich, Margaret Liang, Betty Petschek, Patricia Molinari, Carlos Rios.

Models Tamara Koczanski and Betty Pia, photographers Kenneth Reed and Mike Utt, framers Chap and Danica Capin have been crucial in getting ideas from my head, to hand, to canvas and paper, to print.

Friends and helpers invaluable in many other dimensions: Angel Morales, Devon Pfeiffer, Judy Luster, Mark Levy, Gerrrardo Santana, Barbara Kelly, Myoko Tsuda, Kay Keller, Jane Powell, Elizabeth Powell, Phillip Pollock, Karine and Yvonne da Costa, Anastasia Xenias, TV and radio host Joe Franklin, the staff of Art Supply Warehouse, Tullo Migliori, Star Wang, Anita di Mauro, Anita Martin and the South African Airlines Ft. Lauderdale team.

Tony Lee Zhicong, John Cardamone, Bert Dovo, Rebecca Yeh, Izabella McKamy, Ben di Sarro, Rita Troschinski, Jeffrey Palmer, Patty Jo Provenzale; Anna, Manolo, Fernando, Francesca and Karen-Son Salas, Rutger Sjostrand, Barbara Halpern, Jon and Dale Learn, Tom Kauffman, Monica McLin,Charles Donahue.

Translator Fan Meijing 範美静

Without Fan Meijing I would never have had this initial manuscript translated into Chinese. The high trust level necessary to weave a scaffold of concepts into singular thought via two minds, two languages, requires a search too daunting to even begin.

Miraculously she stepped into my life reviewing my Olympic stone series exhibition for the Shanghai Daily News. Young, feisty, funny, jaded, hip, wise, energetic, curious she danced hexagrams in print around the history of my peripatetic life, pouncing forth with a better perspective on me than I had ever acquired for myself.

Watching her write dozens of features week after week for the SCOPE section of her newspaper, I knew her editor, too, had no qualms about assigning her most anything: history, travel, art, fashion, local nostalgia, cultural affairs. Like a curious dedicated scientist she unravels, considers, observes, describes, assembles, assumes, sums up in great complexity as many subjects as she is given to explore.

She can make jokes with me in English that require a leap, on my part, to a level I have never recognized, using words in her unique oblique style.

So I see this book as a team effort: "Fan Fan", the spirit of Iris and me. I hope you Chinese readers compliment her at the level she deserves. The ideation she creates here, for you, I know will be beyond normal translation standards.

Jacquelyn Thunfors

Index

57. Roe vs. Wade (Pendulum of Life)-bronze architectural model-22 1/2" x 11"x 12 1/2"h		
59. Caterpillar Man	28" x 36" pastel	Illinois Collection
60. Top-Lake Michigan Forever- motorized acrylic-40" x 40"		" "
60. Bottom-Grandmother Anderson's Hat	18" x 25" pastel	" "
61. Top-Social Worker	20" x 38" pastel	" "
61. Bottom-Living the Weather or Not Life	30" x 44" acrylic	" "
62. Lower-Green and Blue Morning	25" x 38" pastel	Greek Collection.
62. Upper-Triangulated	18" x 25" pastel	Illinois Collection
63. Upper-Keeper of the Planet	25" x 36" pastel	U.S Collection
63. Lower-Model Jon Anderson	25"x 36" pastel	" "
64. Man vs. Nature	24" x 60" acrylic	Wales Collection
65. "Get a donkey! The mattress is here!"	20" x 20" acrylic	Greek Collection
65. Upper-Free Pension Including Angel	18"x25" mixed media	" "
66. Es Barranc, Soller	20" x 30" acrylic	Spanish Collection
67. Upper-Welsh field	18"x 25" pastel	U.S. Collection
67. Lower-Spirit of Wales	18"x25" pastel	Wales Collection
68. Druid Death Walk	14"x 10" arylic	" "
70. 21st Century Playing Field	52"x 72" acrylic	South African Collection
71. Birth Mother of Us All-South Africa	25"'x 36" pastel	" " "
72. Bonjani Switches To Fly Casting	25"x 36" mixed media	" " "
73. Top-Black Moon Rising	18"x 25" pastel	" " "
73. Lower-Planetary Menu, Limited Time	20"x 35" acrylic	Greek Collection
77. Spirit of Hawaii		36"Square Silk Scarf
78. Hidden Hosts:The Waiters of Hydra		" " " "
79. Paris Blues		" " " "
79. Lower-Hawaian Morning		" " " "

Closing Images:

Either share with me the library of your life
so I can understand its shoes or try to talk
with me, without words, so we can step
together beyond our historic enculturation.

Jacquelyn Thunfors